THE ANIMAL KINGDOM

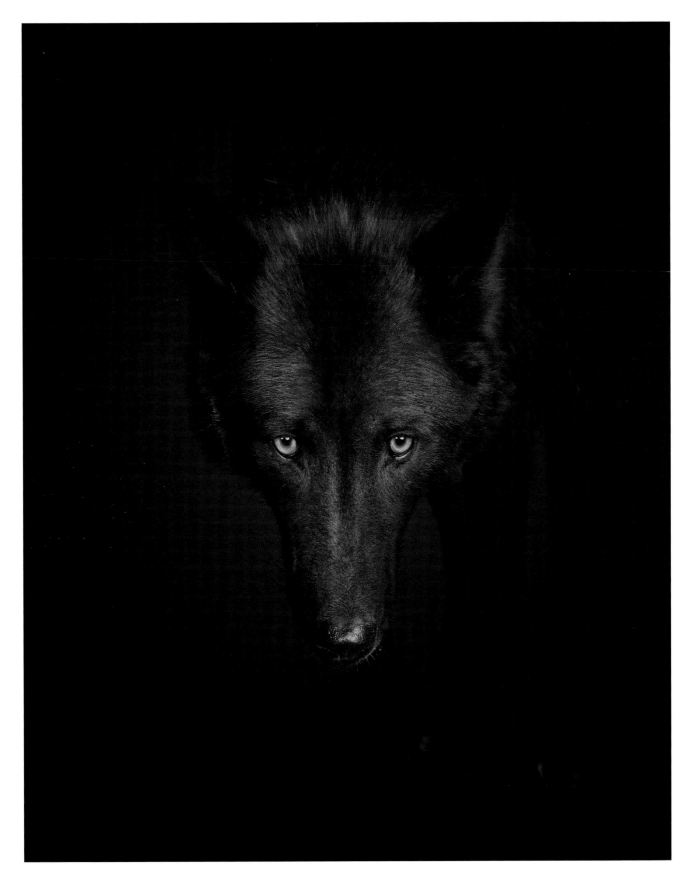

Geronimo

THE ANIMAL KINGDOM

A COLLECTION OF PORTRAITS

by Randal Ford

RIZZOLI
NEW YORK

New York Paris London Milan

First published in the United States of America in 2018 by
Rizzoli International Publications, Inc.
300 Park Avenue South
New York, NY 10010
www.rizzoliusa.com

© 2018 Randal Ford
Foreword by Dan Winters

Associate Publisher: James Muschett
Design: DJ Stout and Carla Delgado, Pentagram Design

2018 2019 2020 2021 / 10 9 8 7 6 5 4 3 2

Printed in China

ISBN-13: 978-1-5996-2147-0

Library of Congress Catalog Control Number: 2018937212

Proceeds from the sale of this book benefit Project Survival's Cat Haven.

Project Survival's Cat Haven is an innovative park dedicated to the preservation of
wild cats. It specializes in education and is engaged in both captive and range country
conservation. It is this link to the conservation of cats in their native habitat that
makes the work of the Cat Haven especially meaningful. While some of the cats at
Project Survival have been orphaned in the wild or have needed to be re-homed due
to varying circumstances, we do not call ourselves a sanctuary. We provide excel-
lent homes for all of our cats but our focus is to educate people about the plight of
endangered cat species, and to raise funds for the conservation projects in the wild.
Working to mitigate problems between cats and people in the wild, these projects are
vital to protecting and conserving these beautiful animals. Project Survival is a 501 c 3
non-profit organization. For more information, please visit https://cathaven.com.

FOR MY WILD THINGS — LAYLA, ELLIS, AND EVERETT

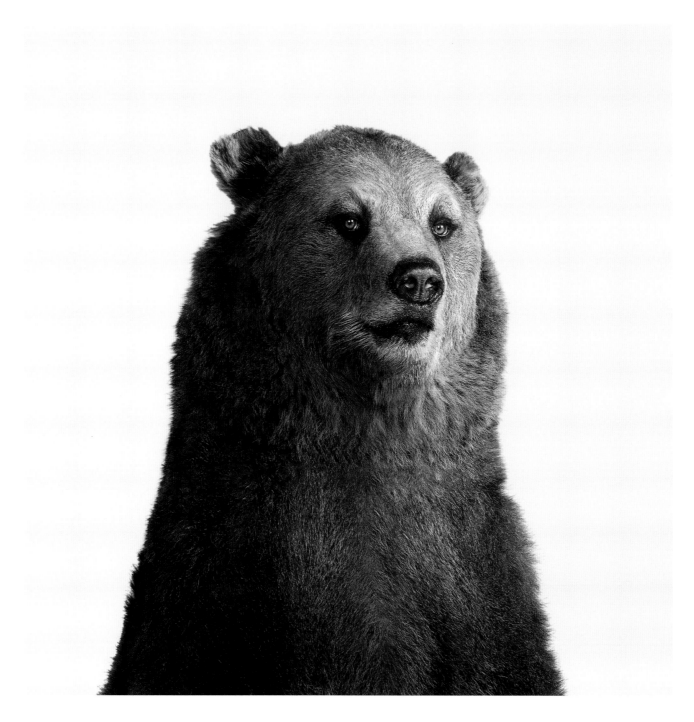

Bam Bam

GRIZZLY BEAR

OVER 40,000 YEARS AGO, we began to depict animals in cave drawings. Throughout history, mankind's consistent artistic portrayal of animals is a testament to the importance of our connection with the animal kingdom.

As mankind evolved, so did our artwork. We began to not only depict, but personify animals. We began to see our human emotions in animals. This anthropomorphism, or personification, connects us to animals on a deeper and more emotional level.

This book is my perspective and portrayal of the animal kingdom. As a portrait photographer, my intention is for these animal portraits to speak to you. What they say depends on the conscious and subconscious feelings you embody.

By photographing each subject in a studio on a neutral background, I am creating a portrait that is focused on the animal only. This deconstructive approach to portraiture allows you to experience the creature in a way otherwise not possible. Through this language of simplistic portraiture, these photographs are aimed to elicit an emotion in the viewer.

Whether it's beauty, power, or humor, I want to give animals the opportunity to tell their story and to connect with you.

— R. FORD

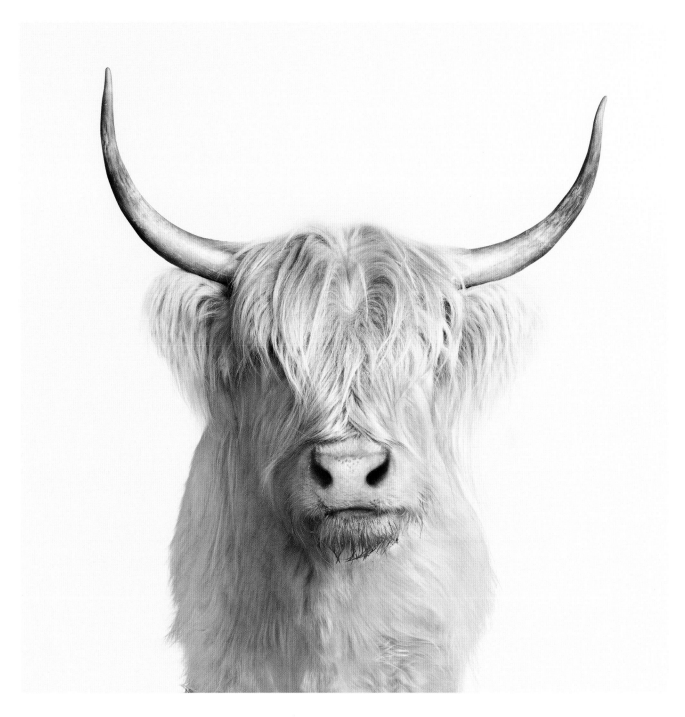

Gertrude

HIGHLAND COW

MR. FORD'S GIFT

AS A PORTRAIT PHOTOGRAPHER of thirty plus years, I make my living with my ability to identify nuance in facial expressions and body language as it applies to human beings. It is a necessary skill, as my portrayal of the sitter does not manifest itself out of the ether. It must be coaxed then captured through careful direction, observation, and decisive reactions. Shared language is used to communicate my intent and achieve the desired results. Upon viewing Mr. Ford's photographs for the first time, I was briefly taken aback, as the primary tool of a portrait photographer—shared language—does not apply to his images, and yet, they appear to be borne of consensual dialogue and collaboration.

The beautiful organisms that have graced Mr. Ford's lens give us a glimpse into a world in which creatures that are often marginalized stand proudly before us.

Wild animals are most often seen in their natural habitats; however, in these photographs they are isolated from the confines of their prosaic environment and elevated through composition and lighting into the sacred forms that they truly are. This use of the studio environment, which eliminates environmental context, acts in the same way that a portrait photographer uses a studio setting to isolate a human subject—this is one aspect of Mr. Ford's photographs that I find so alluring.

Through a mastery of his craft, Mr. Ford has succeeded in removing the filter of our projection and preexisting notions and channeled genuine relatable emotion.

The physiognomy of each creature is elusive to us. Human cues don't necessarily translate. We are, thus, handicapped by our inability to recognize and process a complicated set of visual expressions possessed by a life-form not of our species.

We have been choked to near-death by Disney-type portrayals of animalia that we lack the ability to see them through any set of filters than those that we have absorbed through our culture.

These exquisite photographs go well beyond anthropomorphism. We feel genuine emotion that provides us a cathartic connection.

Mr. Ford has also given us a sacred gift. He has acted as an avatar, and through his efforts, he has allowed us to experience these beasts of the field with an intimacy that is reserved for a select few.

He has conjured a world in which these creatures not only inhabit the same plane but also exist with us as equals. As a result, we respond not with fear but, instead, with wonderment.

— DAN WINTERS

"JABARI, BEDHEAD, MESSY TEENAGER. PART OF THE INTEREST OF THIS SHOT IS THAT HE HAS A YOUNG MANE GROWING IN. THIS IS SO INDICATIVE OF A TEENAGER, WHICH I GUESS IN LION YEARS, JABARI WAS RIGHT ON SCHEDULE."

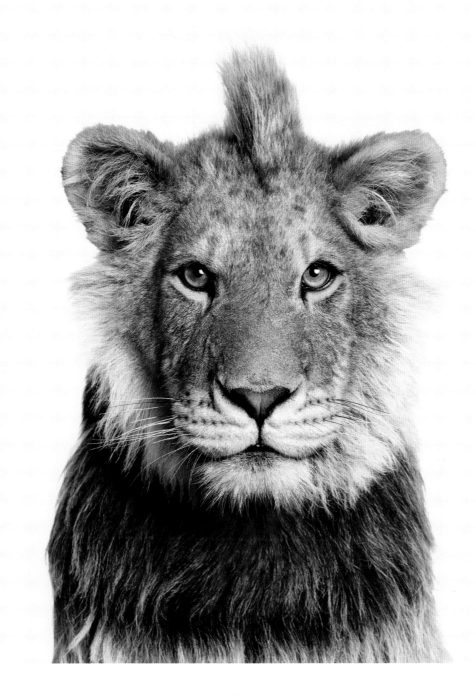

Jabari

YOUNG LION

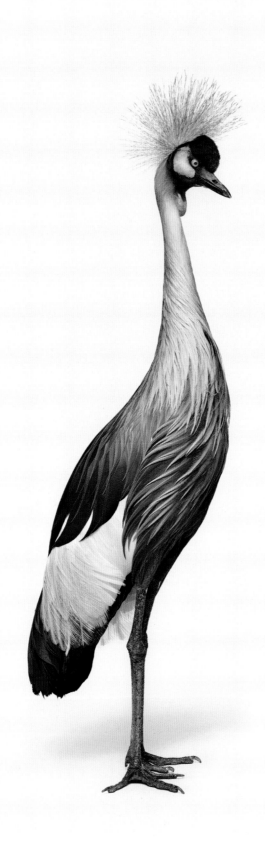

Penelope

AFRICAN CRANE

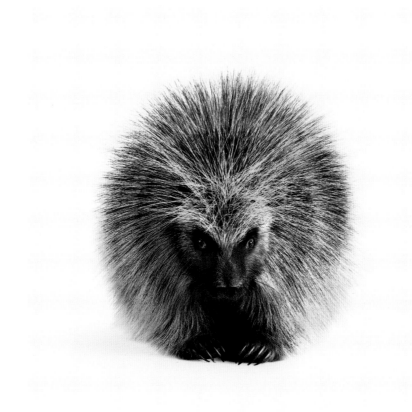

Nora

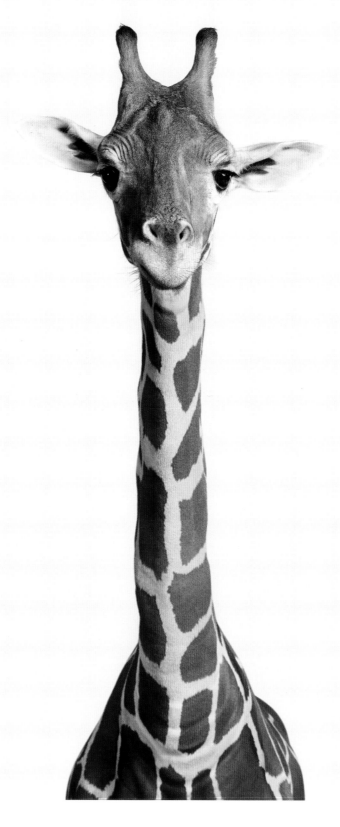

Buddy

GIRAFFE

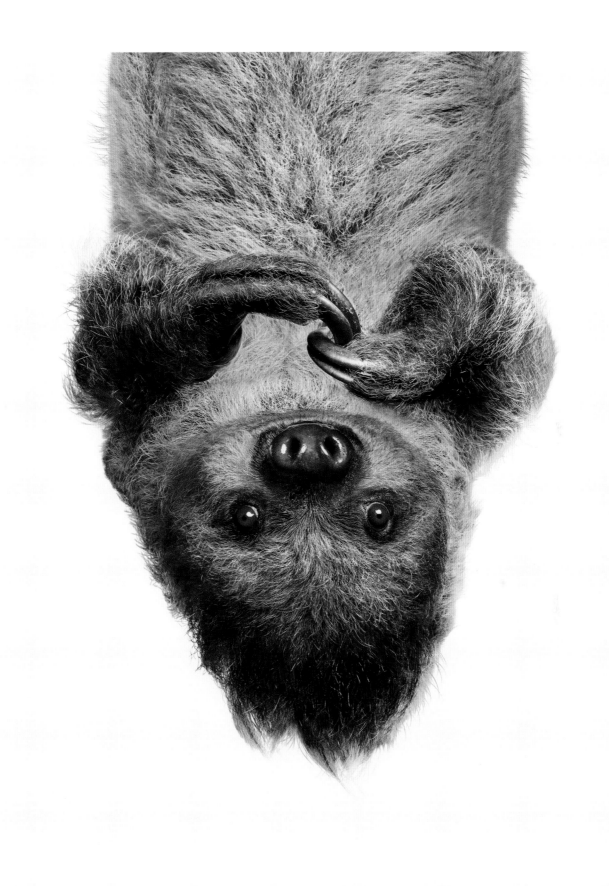

Perry

TWO-TOED SLOTH

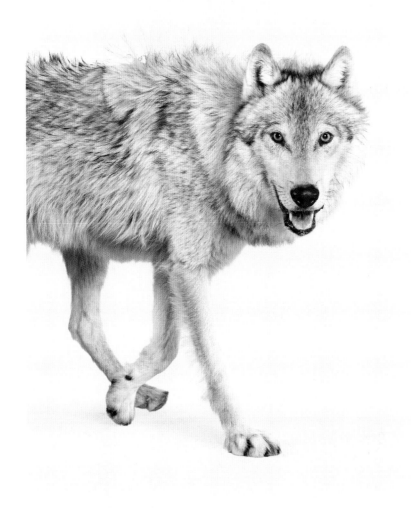

Jagger

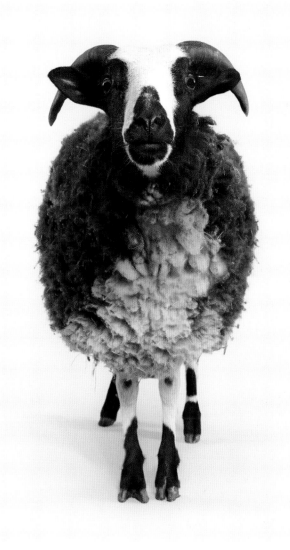

Moses

PLATE 10 JACOB SHEEP FRAME 75/82

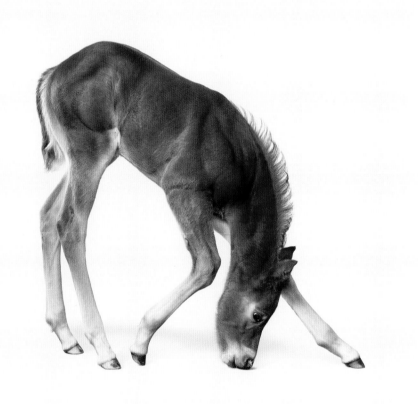

Weston

PLATE 11 FOAL FRAME 15/42

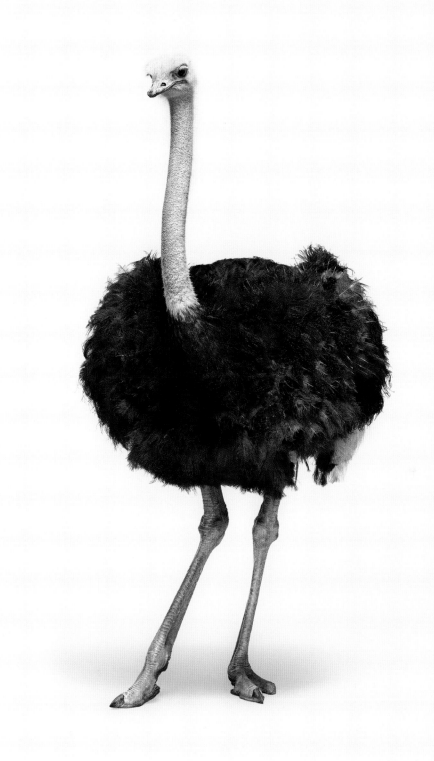

PLATE 12

Catalina

OSTRICH

PLATE 13

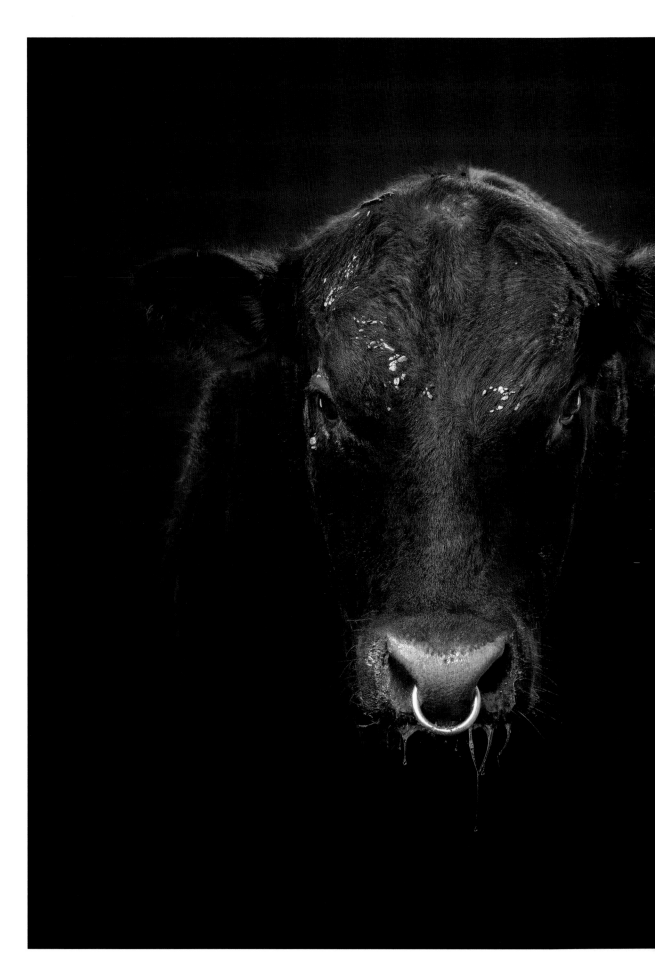

Wayne Crosby
BLACK BULL

"SOME ANIMALS I
PREFER TO BE PRISTINE
AND CLEAN, OTHERS
I PREFER NATURAL TO
THEIR ENVIRONMENT."

PLATE 14

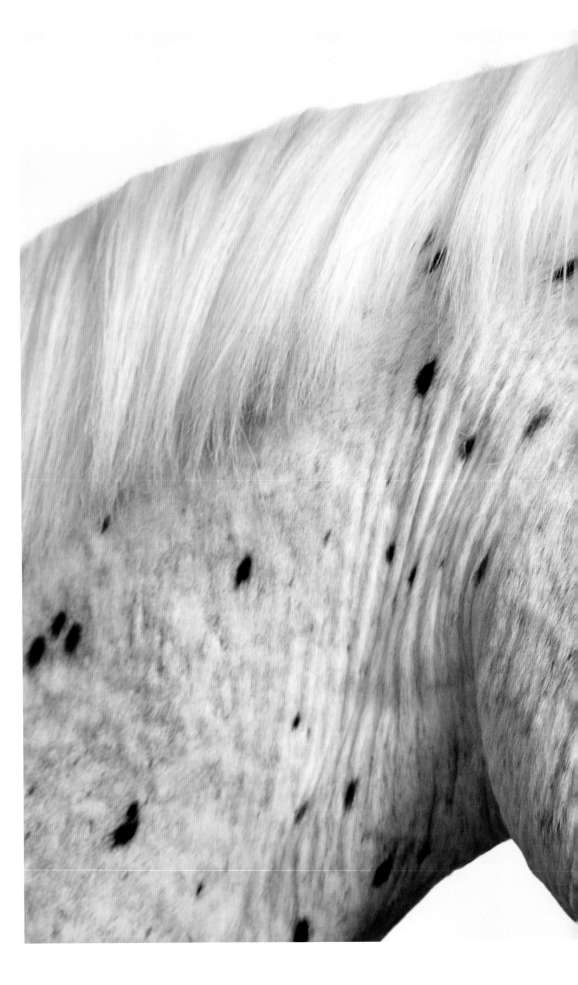

Eva

LEOPARD APPALOOSA HORSE

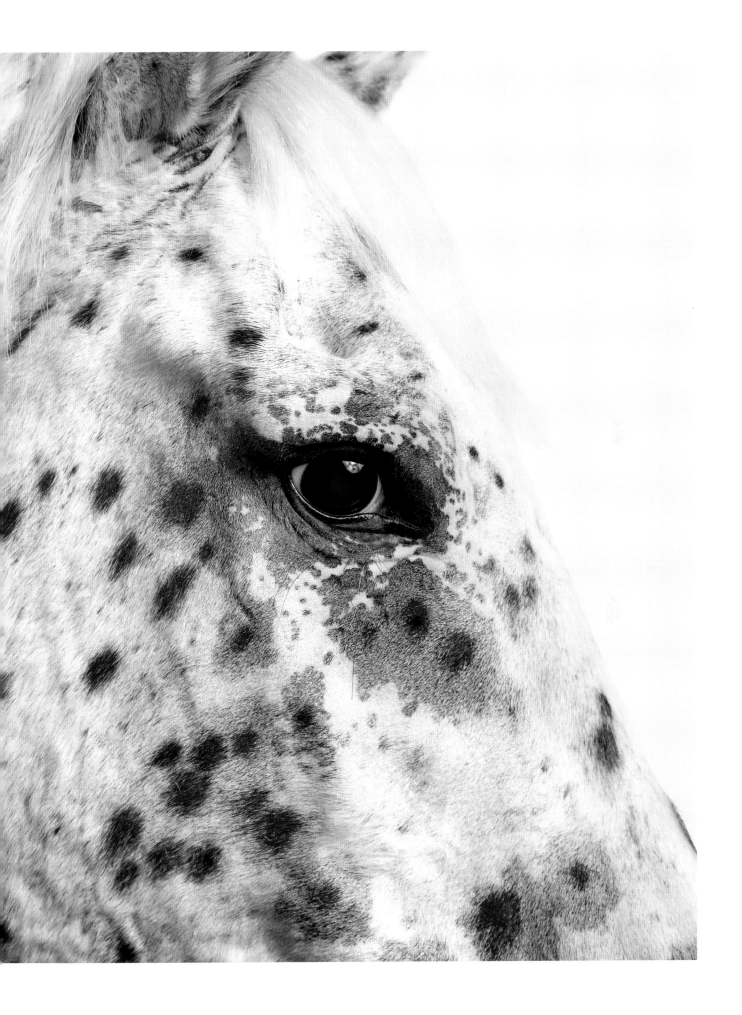

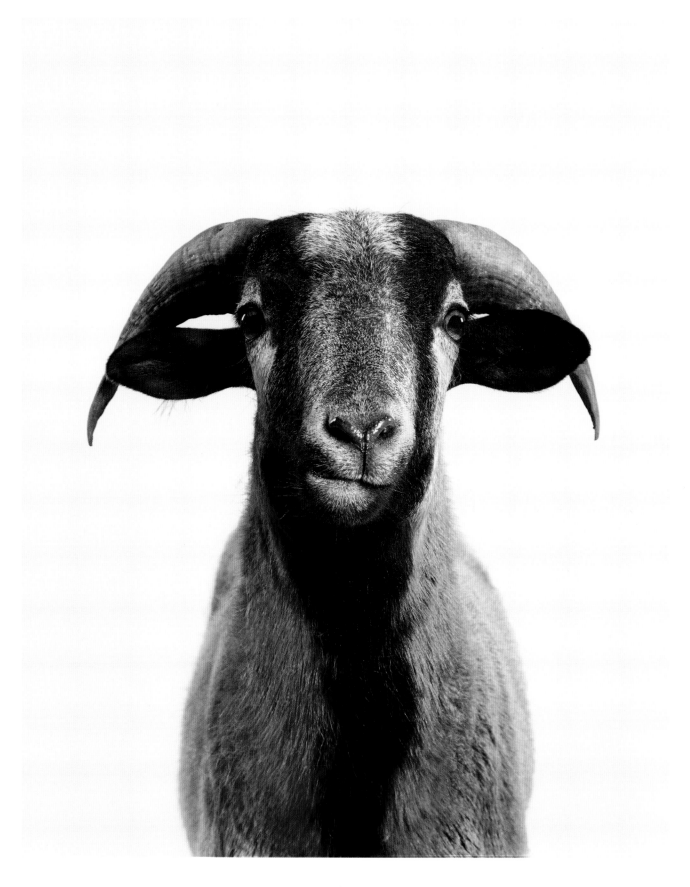

Octavius

PLATE 15

BARBADOS BLACKBELLY SHEEP

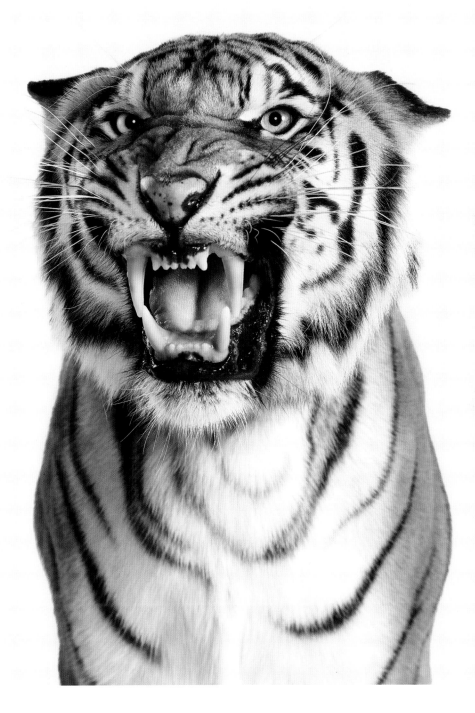

Schicka

PLATE 16

BENGAL TIGER

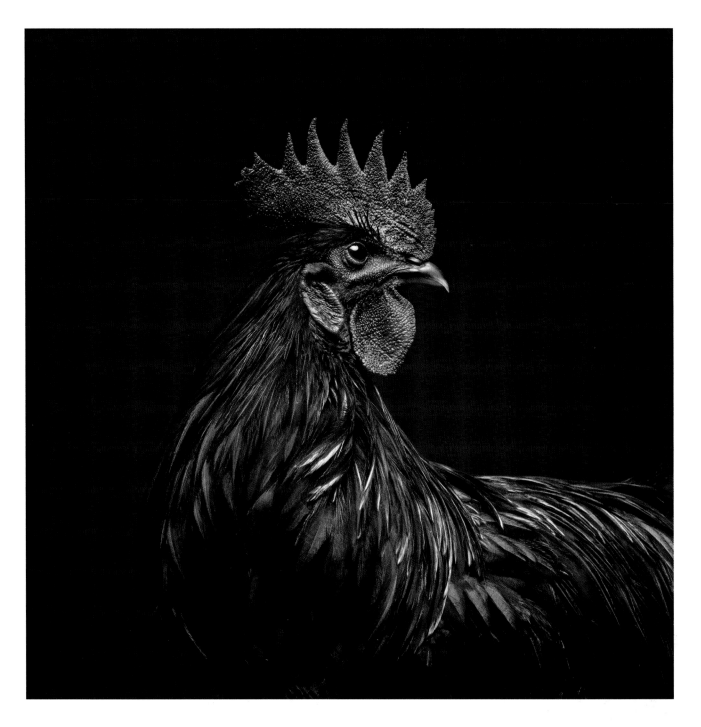

Krishna

PLATE 17

AYAM CEMANI ROOSTER

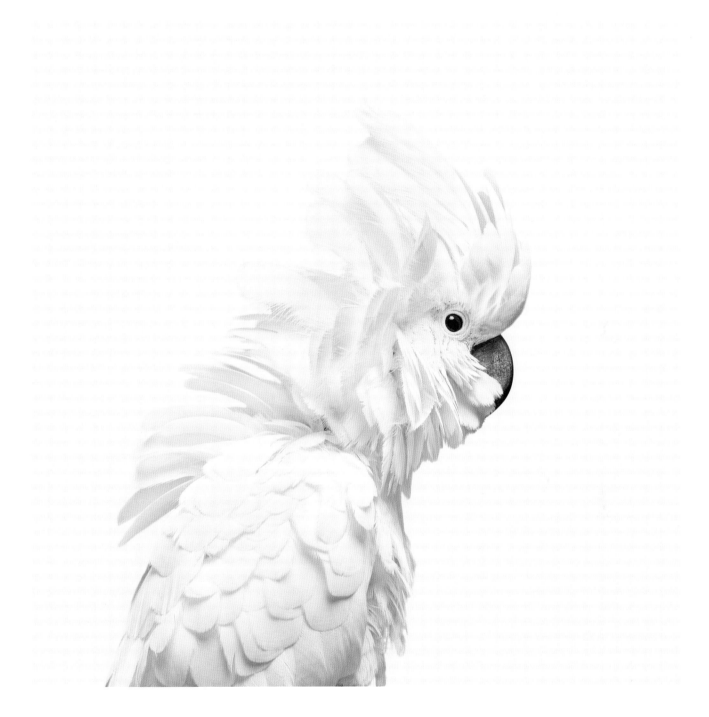

Ruth

PLATE 18 WHITE COCKATOO FRAME 23/78

"I REMEMBER DISTINCTLY
WHEN SCHICKA'S
TRAINERS REMOVED HER
LEASH AND ASKED HER
TO WALK TO THE MARK.
THE WAY SHE WALKED
WAS SO GRACEFUL AND
STUNNINGLY BEAUTIFUL.
BUT I WAS IN THE MIDDLE,
AT HER MERCY. THE
FEELING THAT I COULD BE
PREY WAS CHILLING."

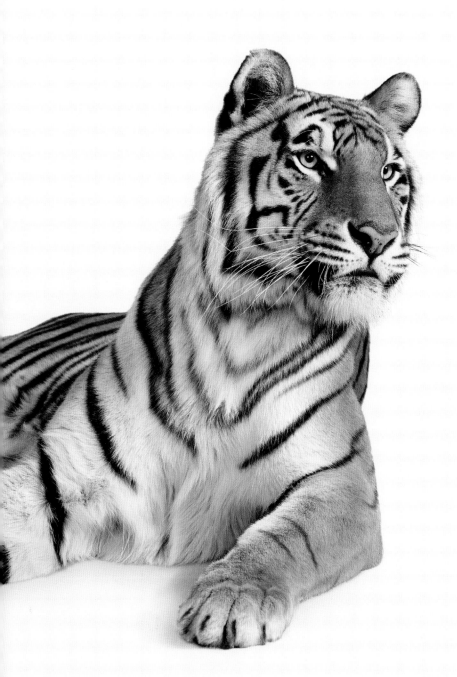

Schicka
BENGAL TIGER

PLATE 19

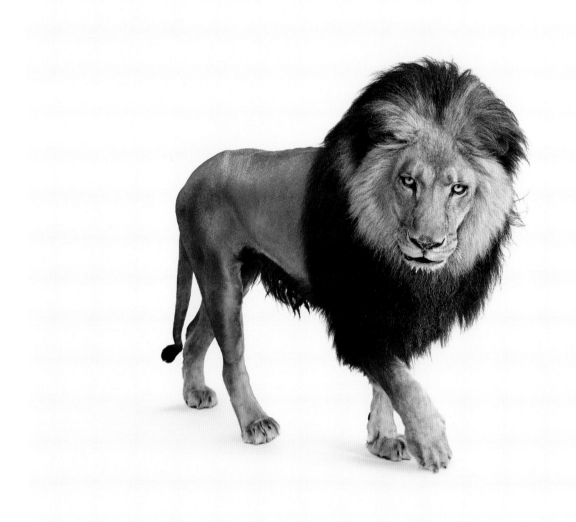

Felix

PLATE 20

LION

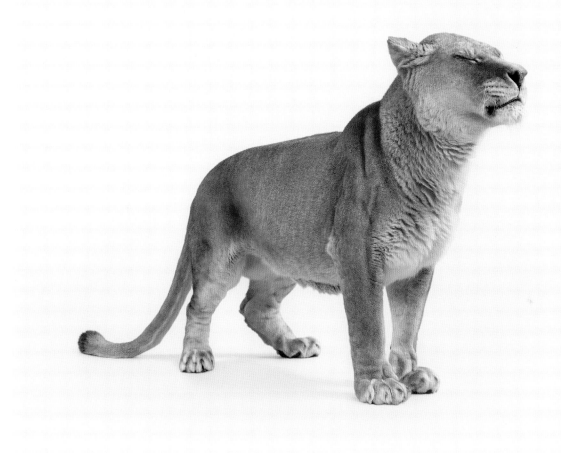

Tuareg

LIONESS

PLATE 21

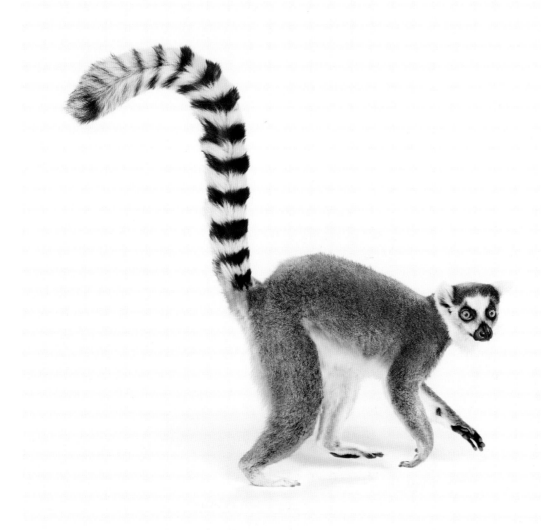

Julian

RING-TAILED LEMUR

PLATE 22

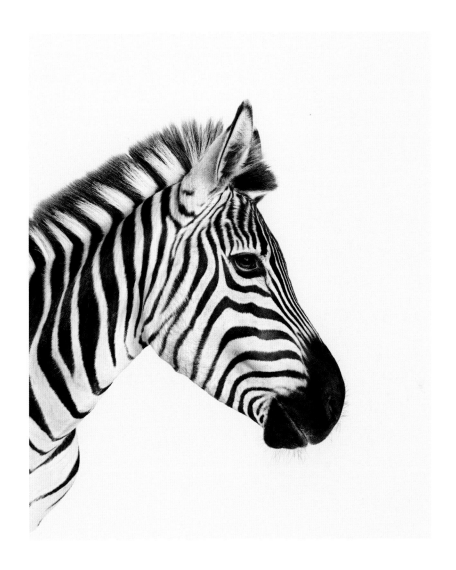

Fez

PLATE 23 ZEBRA FRAME 87/91

"MURPHY HAD ME
ON MY TOES THE
WHOLE TIME. HE HAD
A LOW GROWL THE
ENTIRE SHOOT, BUT
BY THIS TIME I KNEW
THE TRAINERS WELL
ENOUGH TO KNOW
WE WERE SAFE AND
MURPHY WAS SIMPLY
IN HIS 'WORK MODE.'"

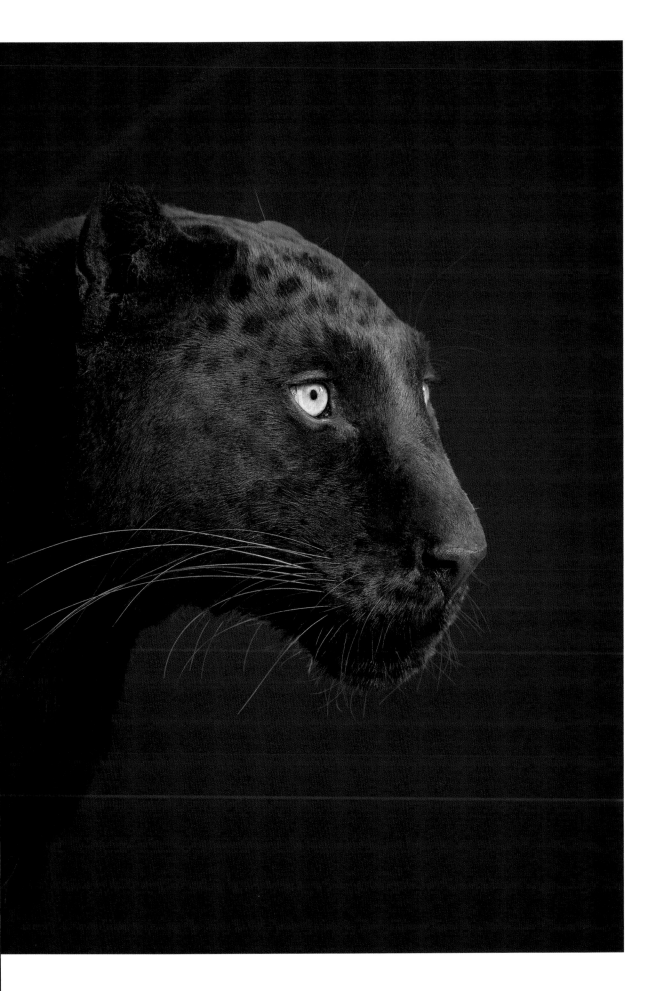

Murphy
BLACK LEOPARD

PLATE 24

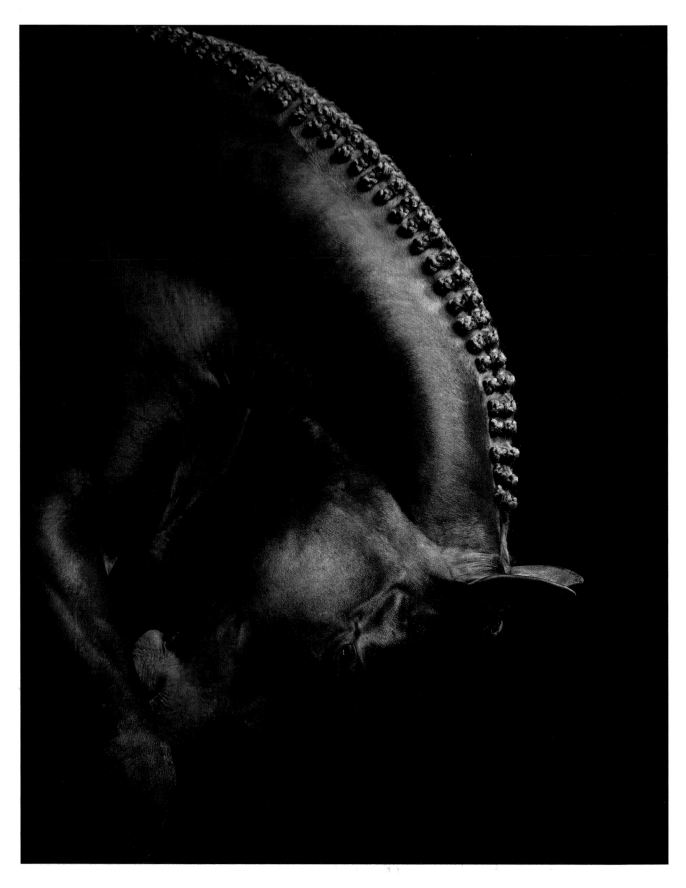

Black Betty

PLATE 25

AMERICAN QUARTER HORSE

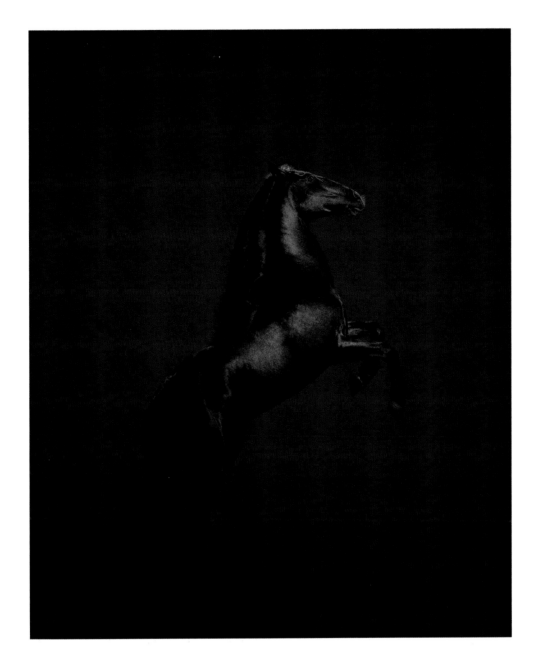

Bastina

PLATE 26

LUSITANO HORSE

PLATE 27

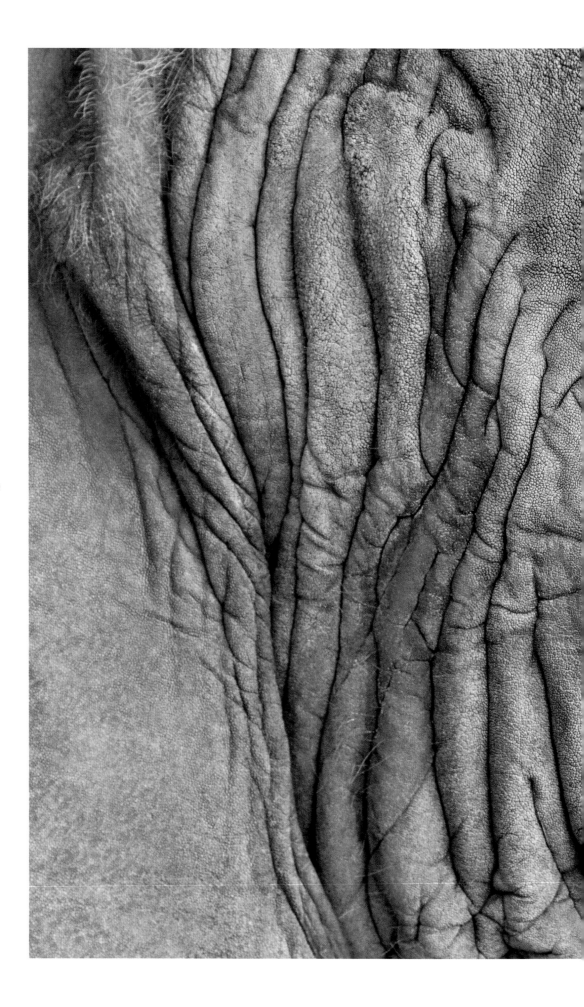

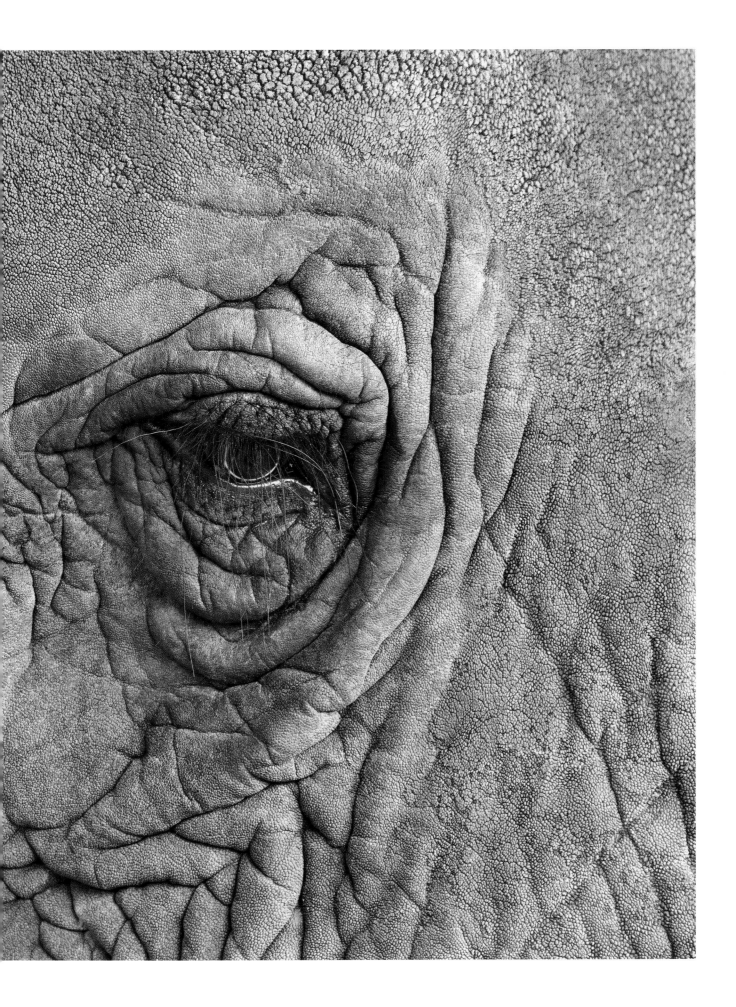

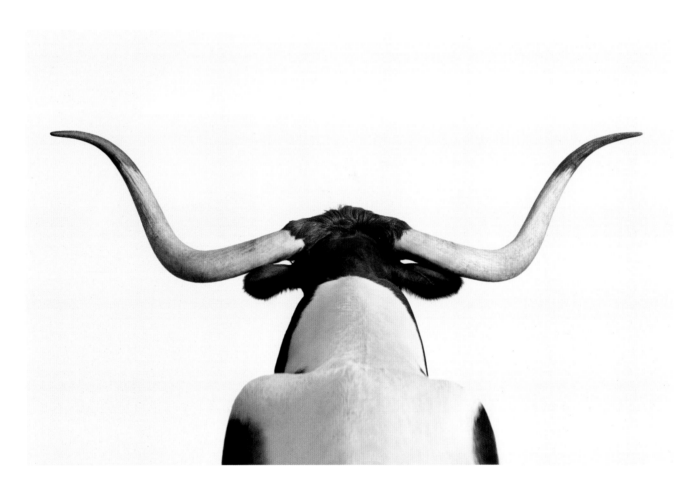

Maverick

LONGHORN

PLATE 28

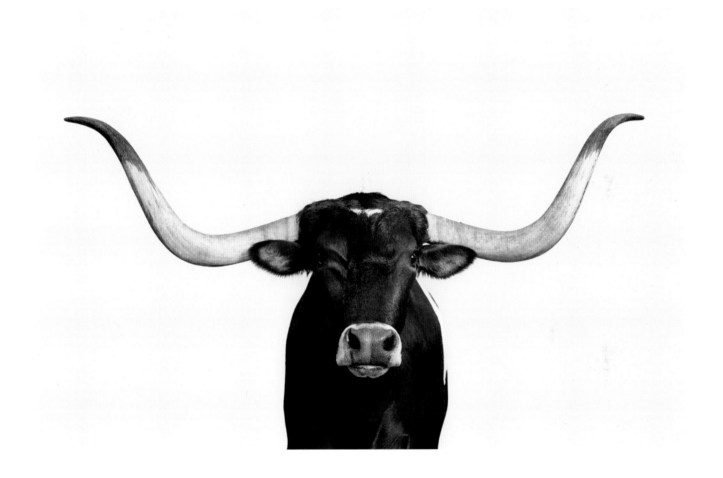

PLATE 29

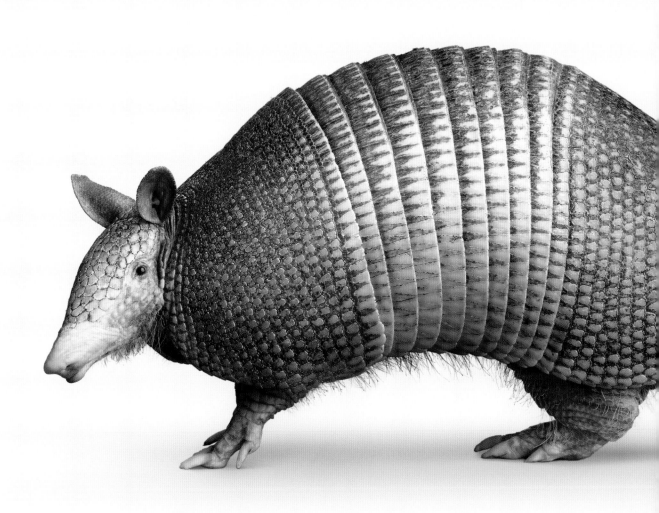

Quesa the Dilla

NINE-BANDED ARMADILLO

PLATE 30

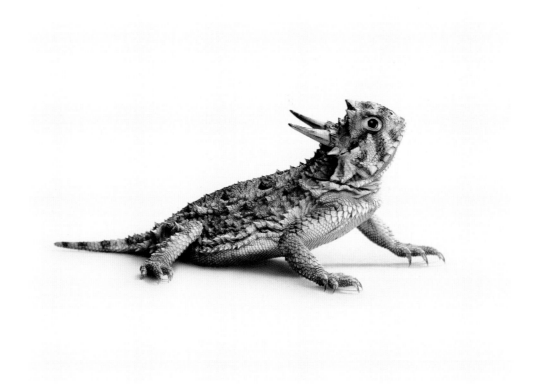

Luke

PLATE 31 HORNED LIZARD FRAME 11/46

PLATE 32

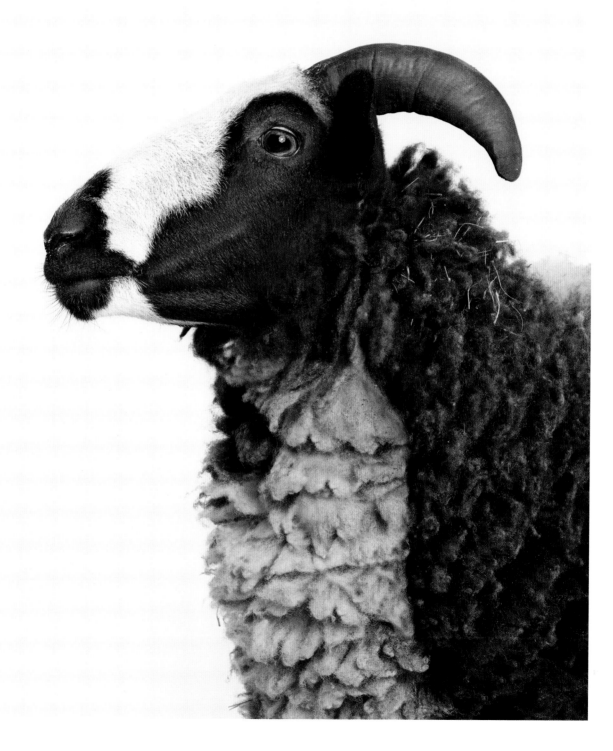

Moses

JACOB SHEEP

"IT IS SAID A SMALL
NUMBER OF BLACK
SWANS EXPLAINS
ALMOST EVERYTHING
IN OUR WORLD..."

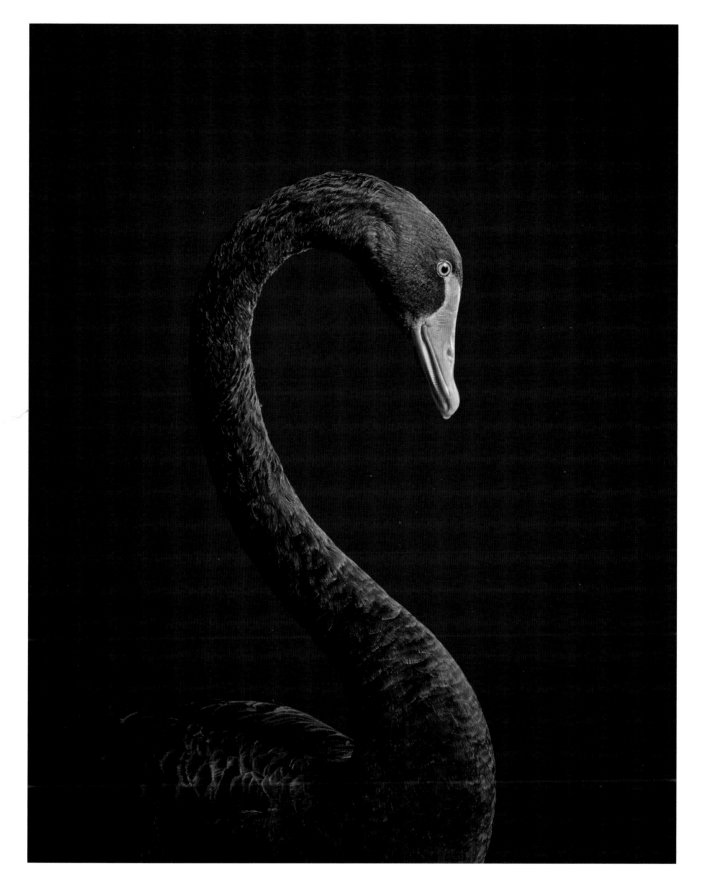

Stefani Angelina

BLACK SWAN

PLATE 33

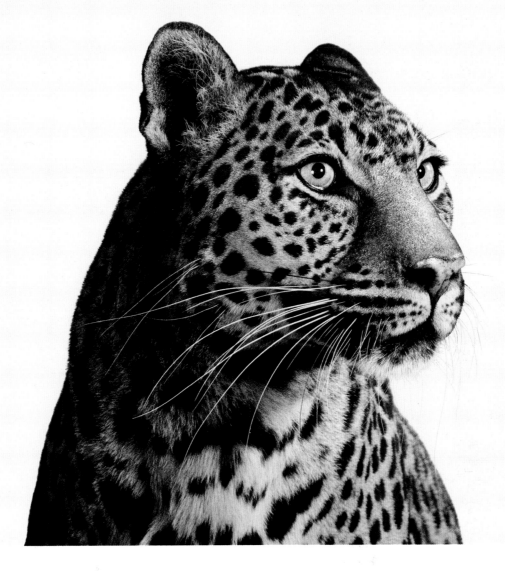

Sheena

PLATE 34

SPOTTED LEOPARD

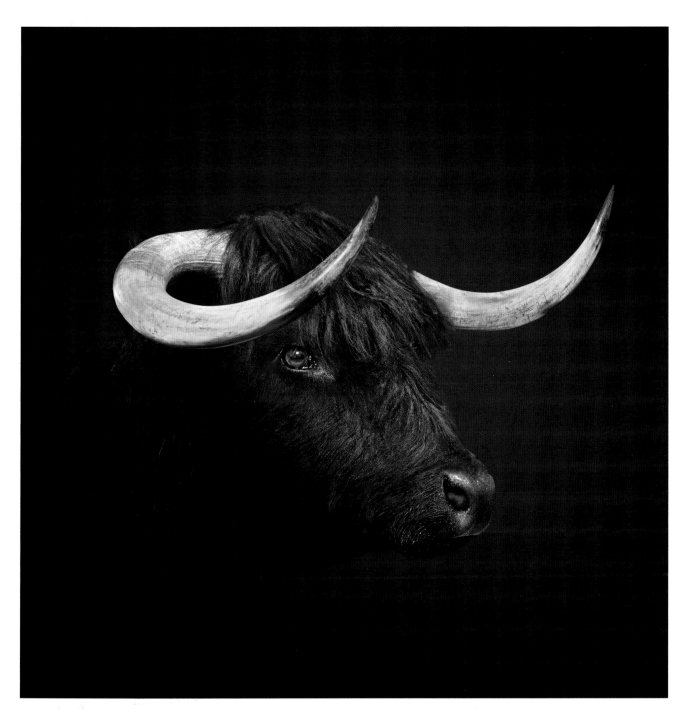

Domino

PLATE 35

BLACK HIGHLAND COW

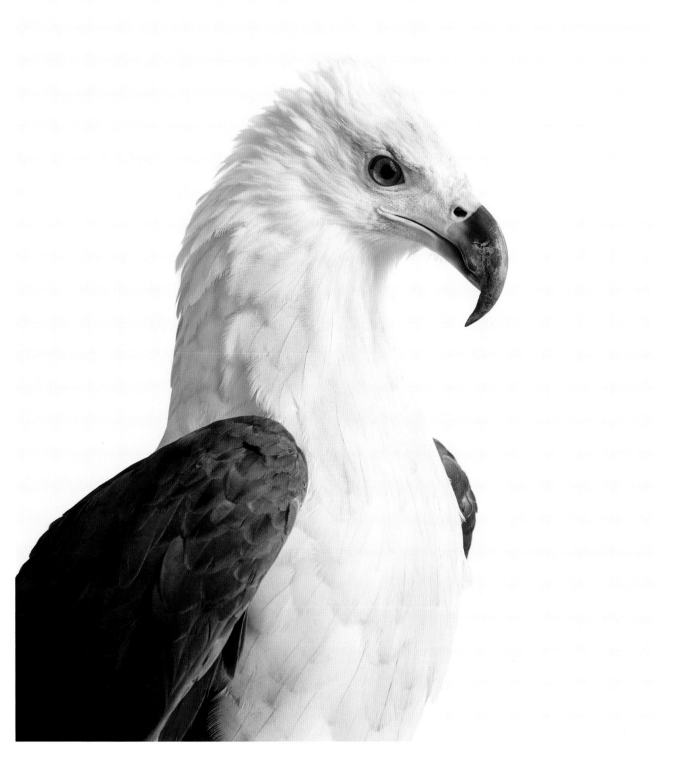

Vincent

PLATE 36

AFRICAN FISH EAGLE

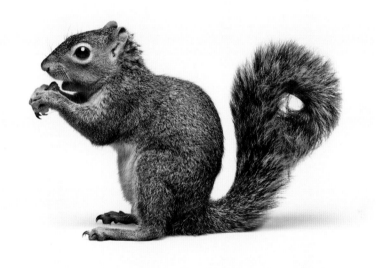

Merle

PLATE 37

SQUIRREL

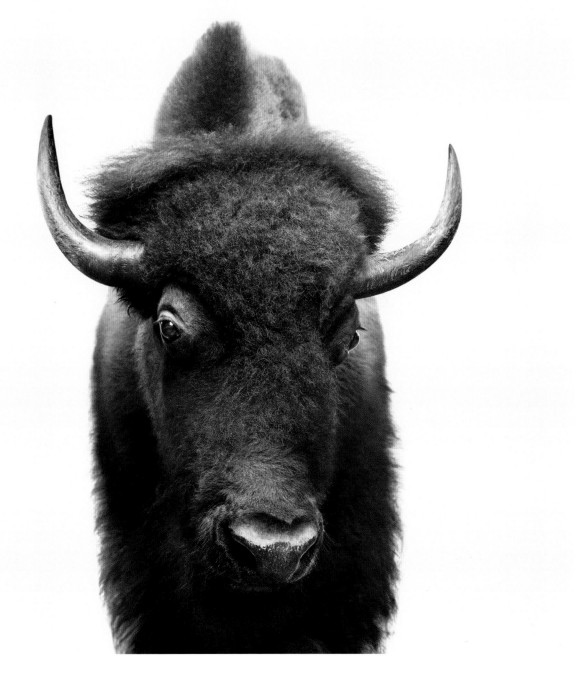

Red Cloud

PLATE 38

AMERICAN BUFFALO

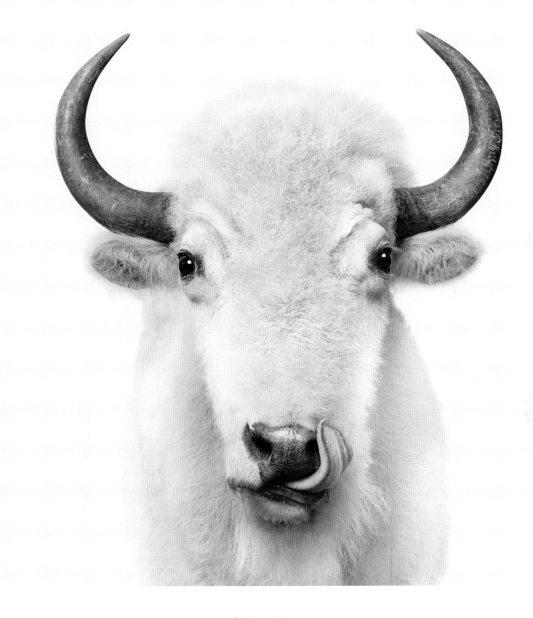

Huckleberry

AMERICAN WHITE BUFFALO

PLATE 39

PLATE 40

Cairo

SPOTTED LEOPARD

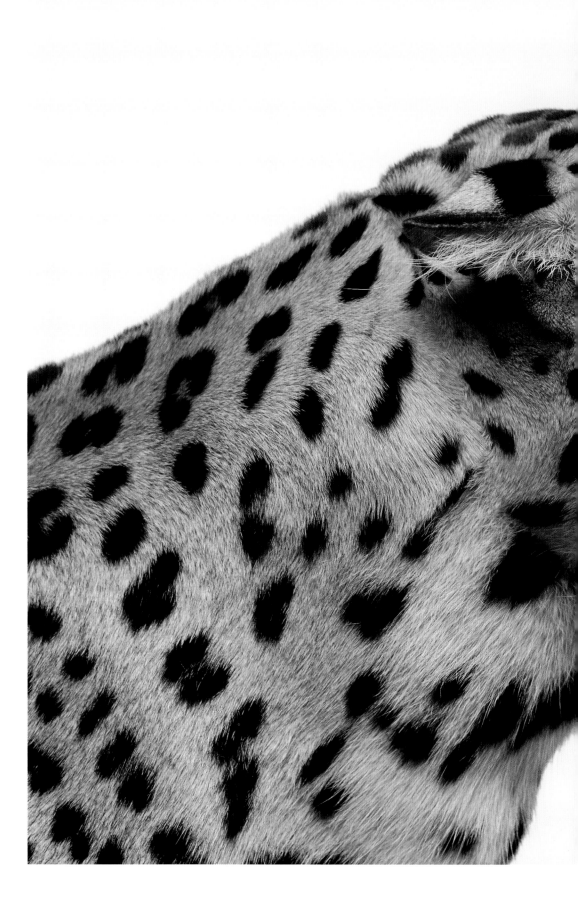

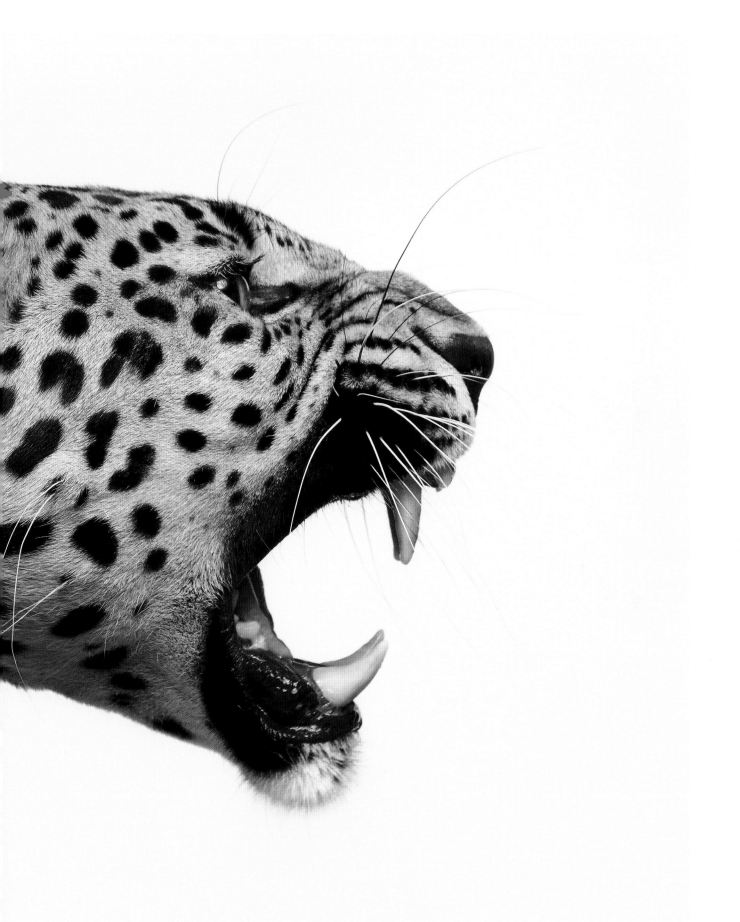

"THE TRAINERS ALLOWED
ME TO PUT MY HAND ON
ELOISE'S SHOULDER AND
FEEL THE WONDERFULLY
UNIQUE TEXTURE OF HER
SKIN AND WRINKLES. I
CLOSED MY EYES AS I
FELT THE RISE AND FALL
OF HER BREATH AND FELT
A SENSE OF GRATITUDE
COME OVER ME. AN
AMAZING MOMENT."

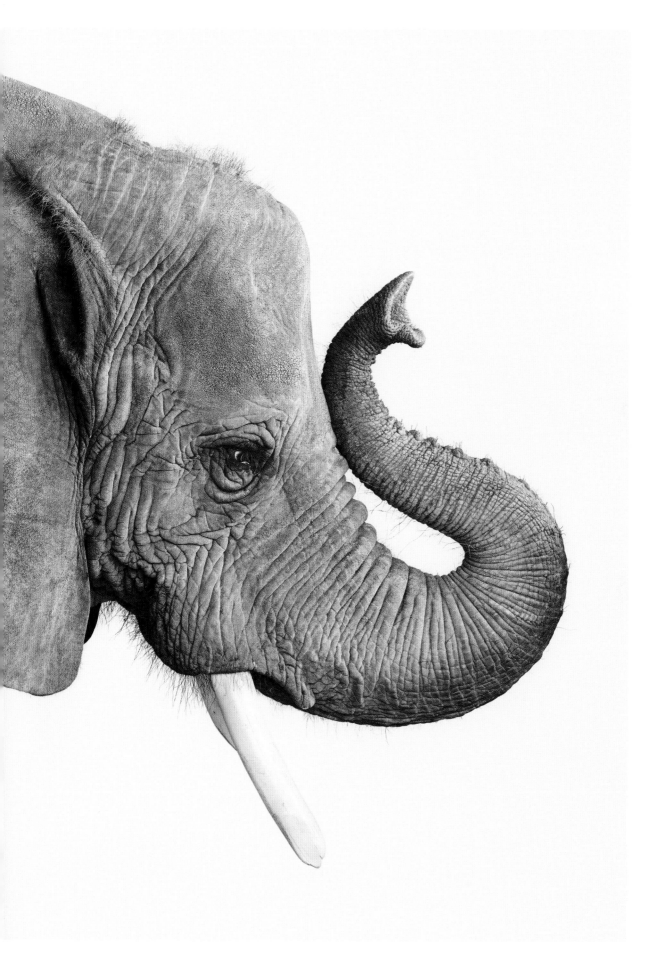

Eloise

AFRICAN ELEPHANT

PLATE 41

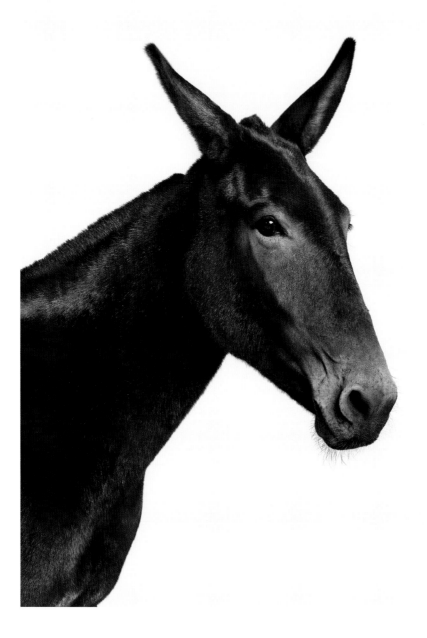

Milo

JOHN MULE

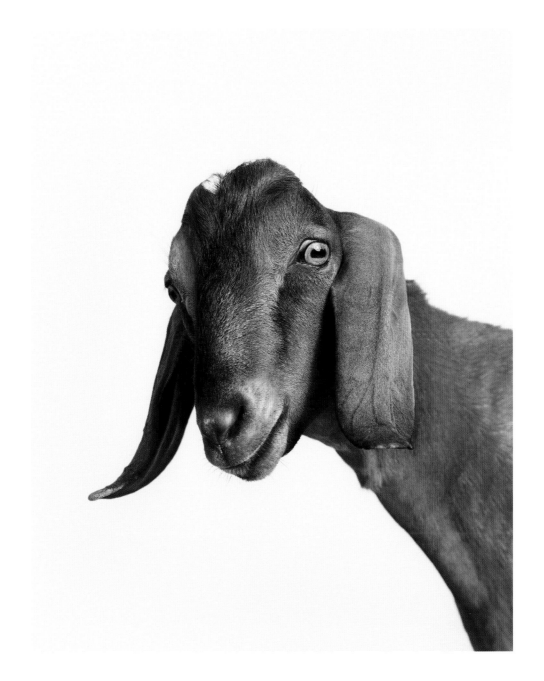

Sammy

PLATE 43

BROWN GOAT

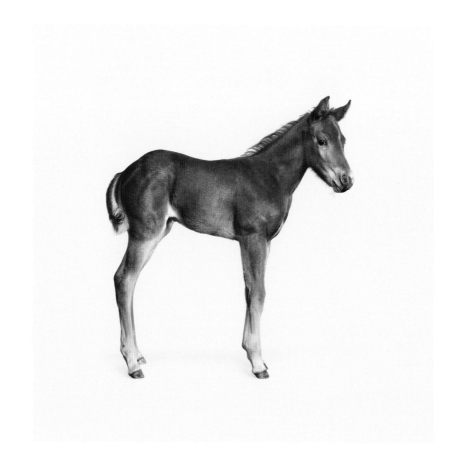

Weston

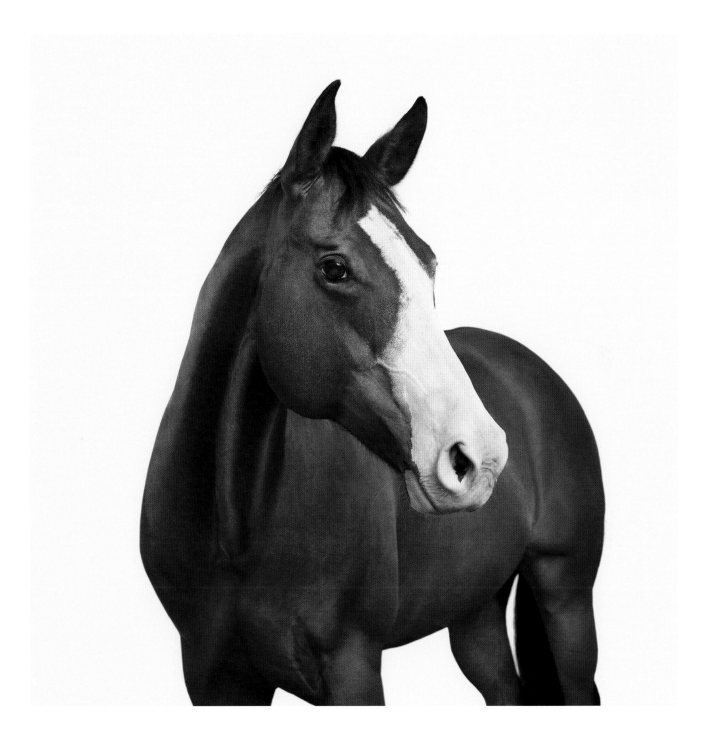

Theodore

PLATE 45

AMERICAN QUARTER HORSE

PLATE 46

Black Betty

AMERICAN QUARTER HORSE

PLATE 48

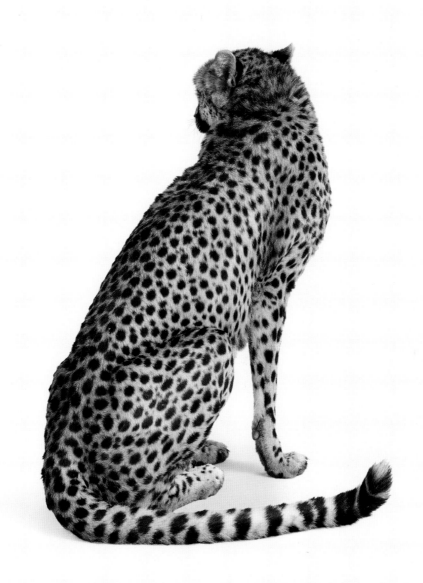

"POPPY'S GORGEOUS
YELLOW IRISES WERE
A FOCAL POINT FOR
HER PORTRAITS. OWLS
ARE ONE OF THE MOST
EXPRESSIVE ANIMALS I'VE
PHOTOGRAPHED. THEIR
EYES TELL A STORY UNLIKE
ANY OTHER CREATURE.
I WANTED TO SHOW THREE
LIKENESSES OF HER: ONE
OF INTENSITY, ONE OF
HUMOR, AND ONE MORE
CONTEMPLATIVE."

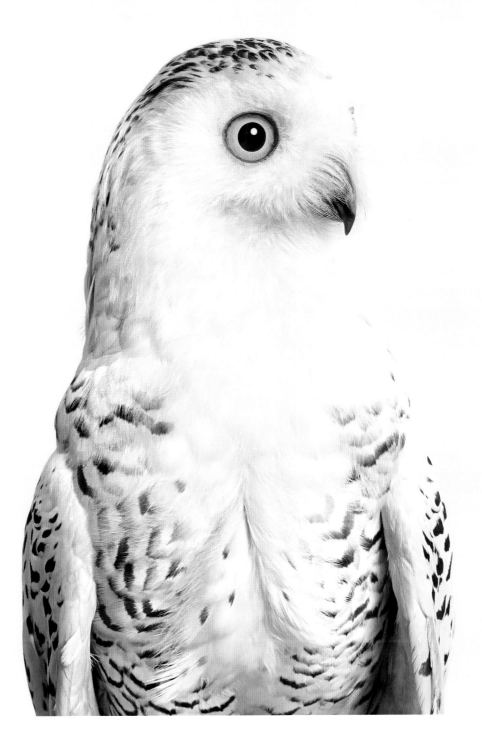

Poppy

SNOWY OWL

PLATE 49

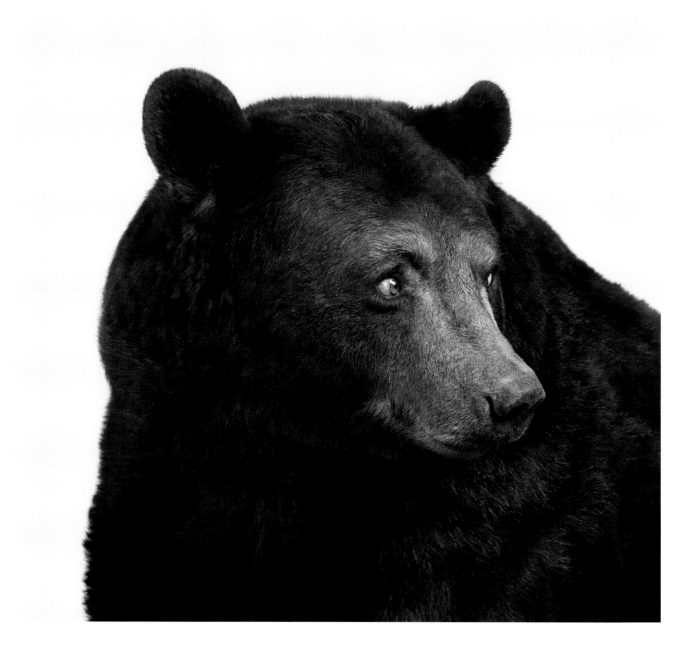

Roberta

BLACK BEAR

PLATE 50

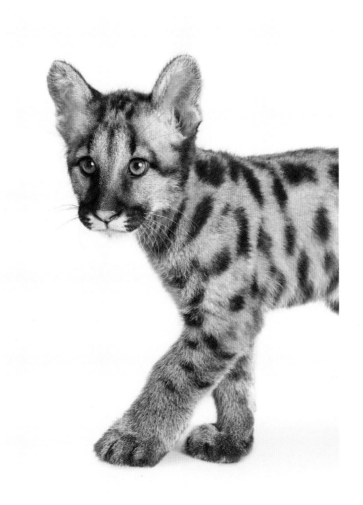

Pete

PLATE 52

Sergeant Pepper

WHITE ARABIAN HORSE

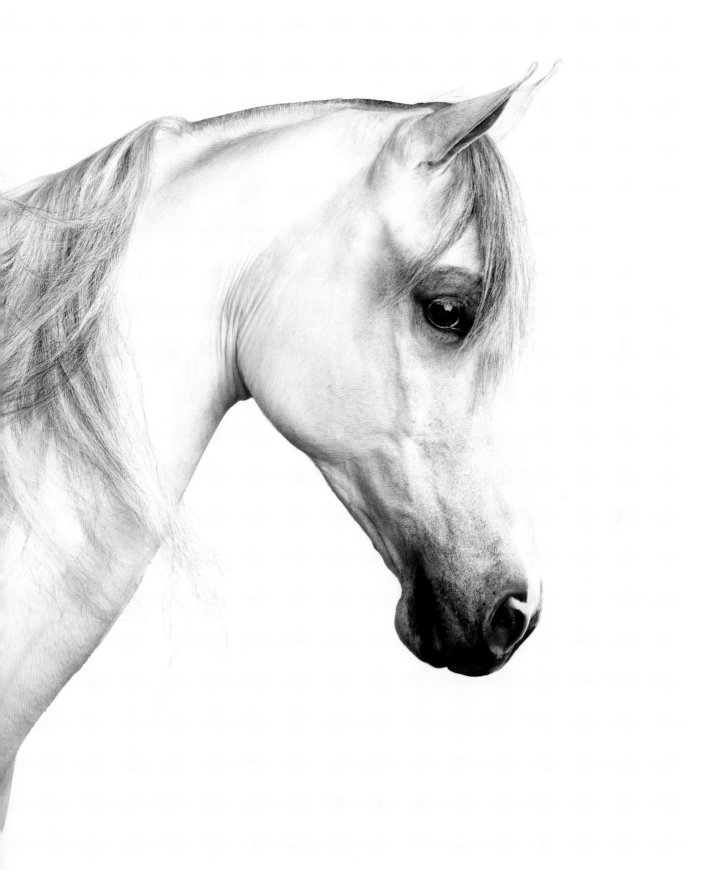

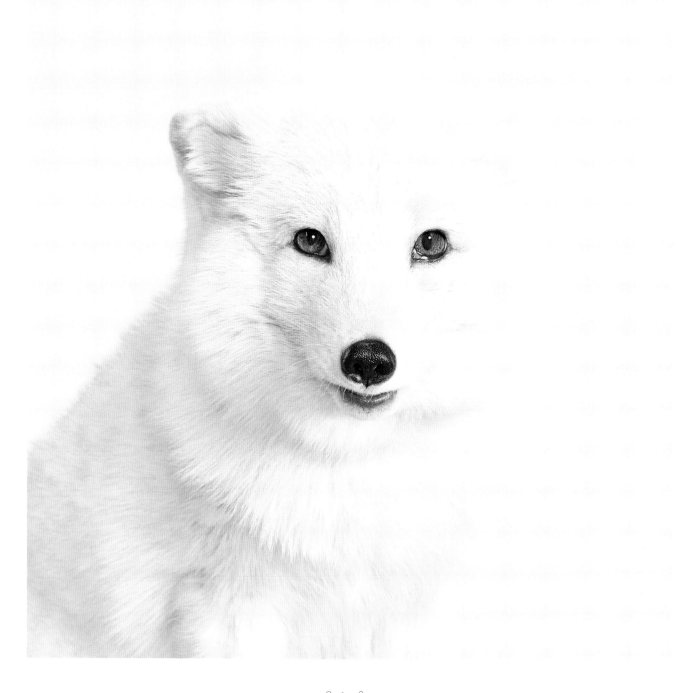

Vicki

ARCTIC FOX

PLATE 53

FRAME 24/26

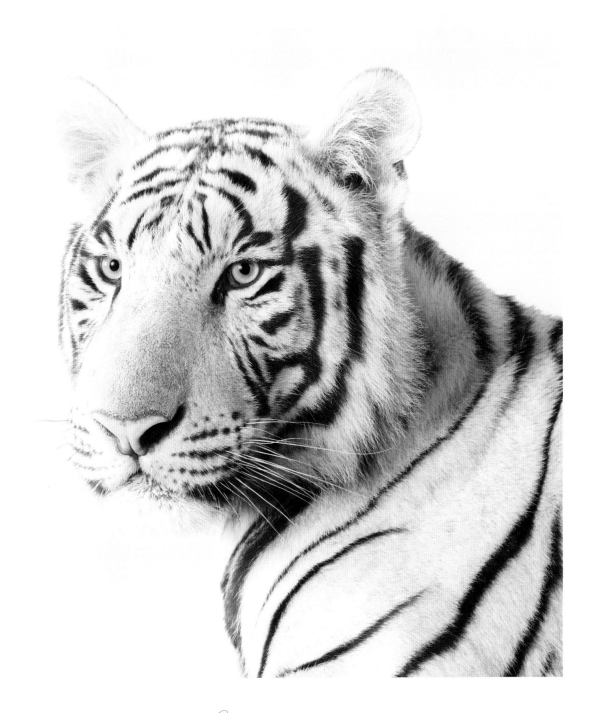

Caesar

SIBERIAN TIGER

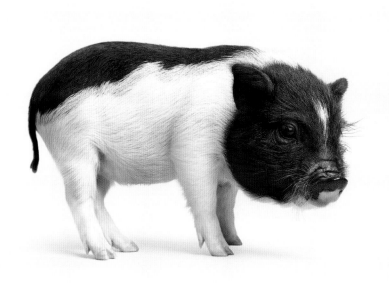

Carnita

PLATE 55

POT-BELLIED PIG

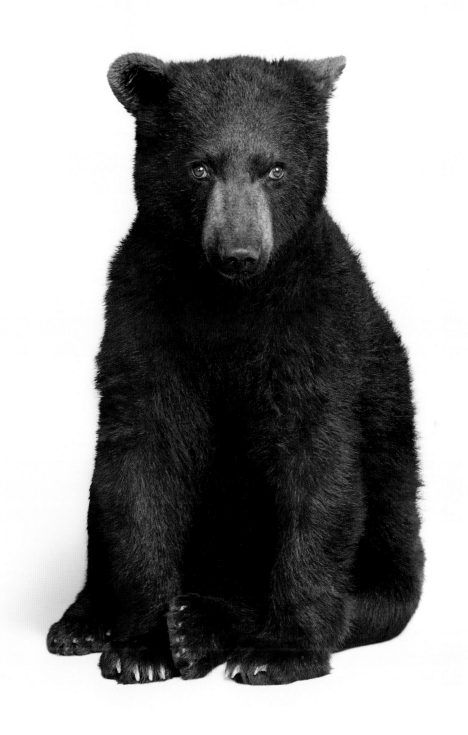

Andre

BLACK BEAR CUB

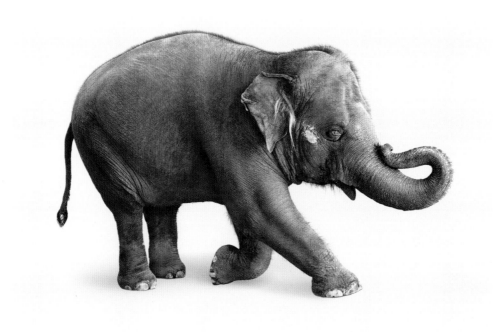

Rosie

ASIAN ELEPHANT

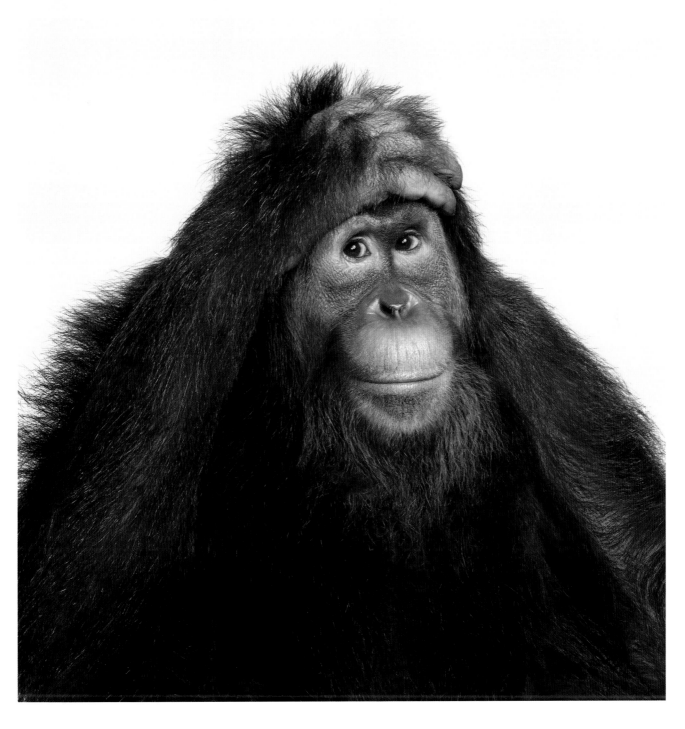

Danielle

ORANGUTAN

PLATE 58

PLATE 59

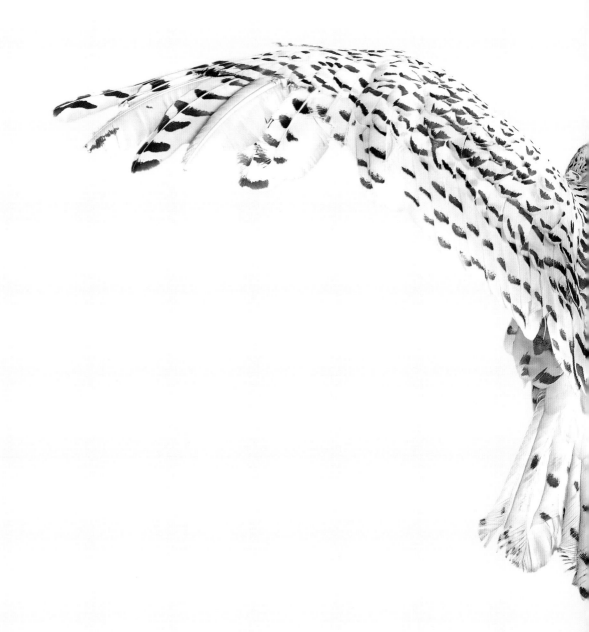

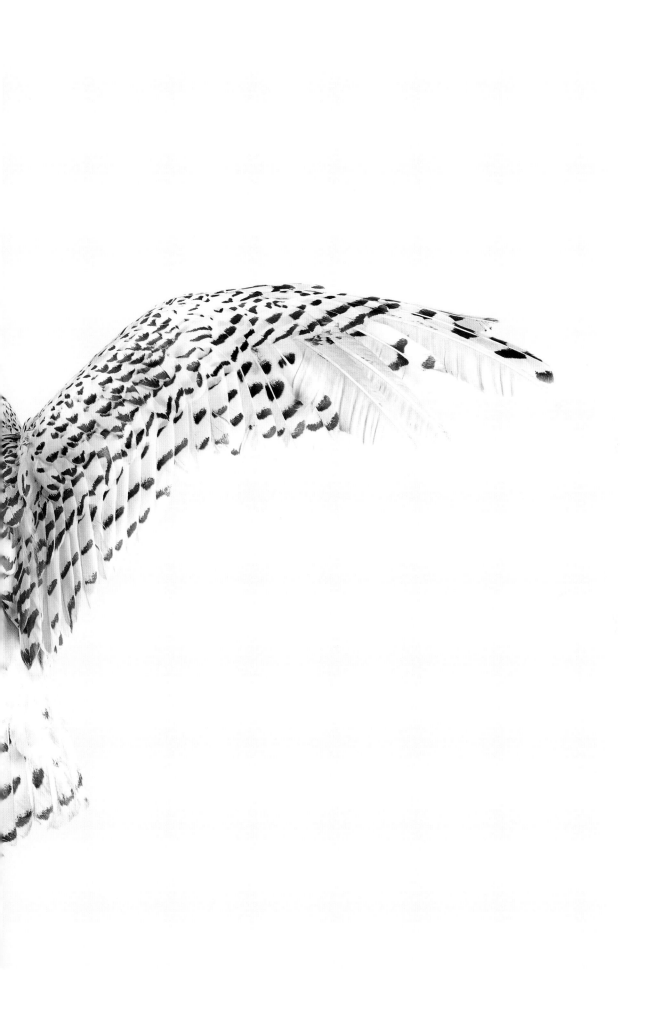

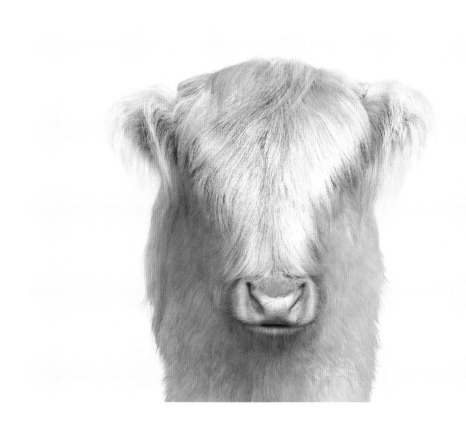

Goldie

HIGHLAND CALF

PLATE 80

FRAME 07/33

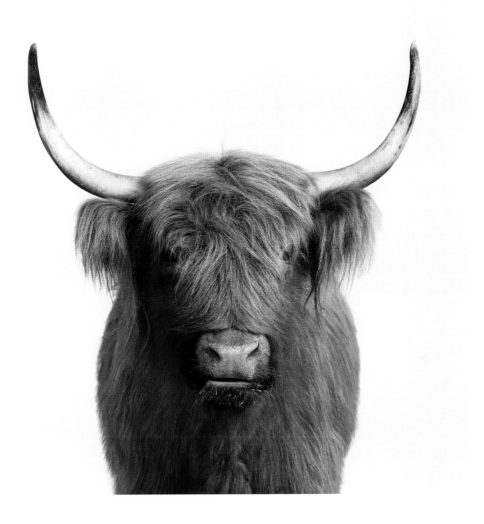

Beverly

PLATE 81

HIGHLAND COW

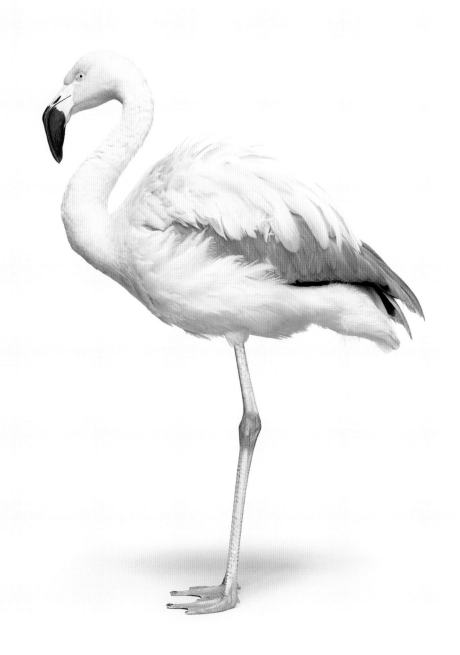

Alejandra

FLAMINGO

PLATE 62 FRAME 44/78

PLATE 83

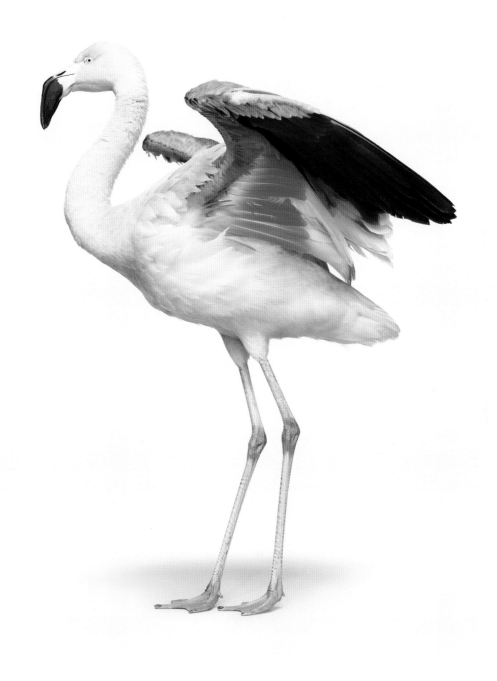

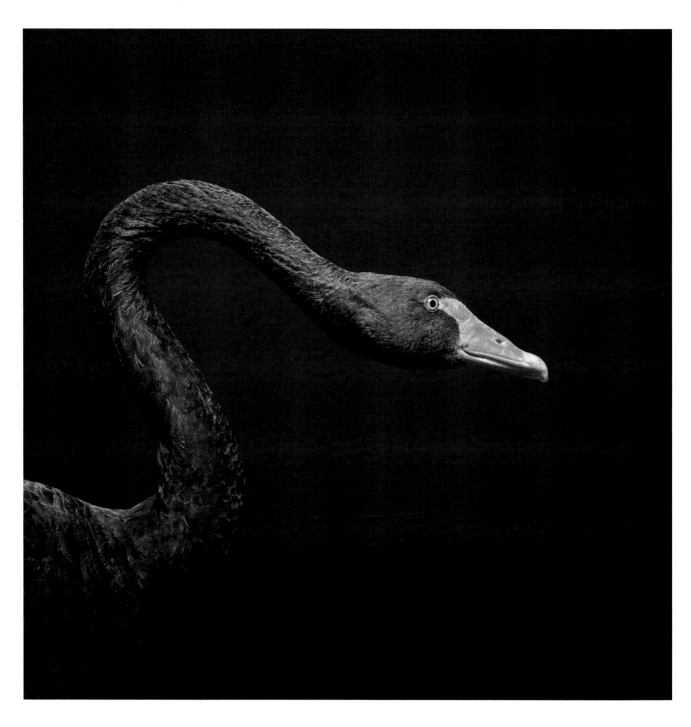

Stefani Angelina

PLATE 64

BLACK SWAN

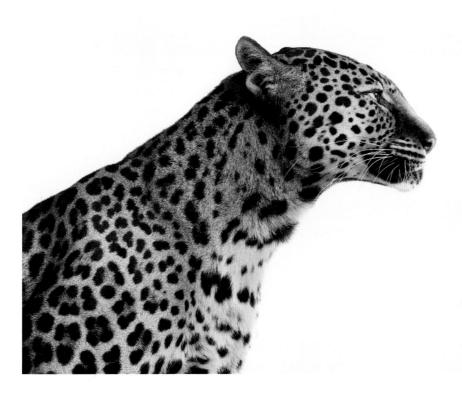

Sheena

SPOTTED LEOPARD

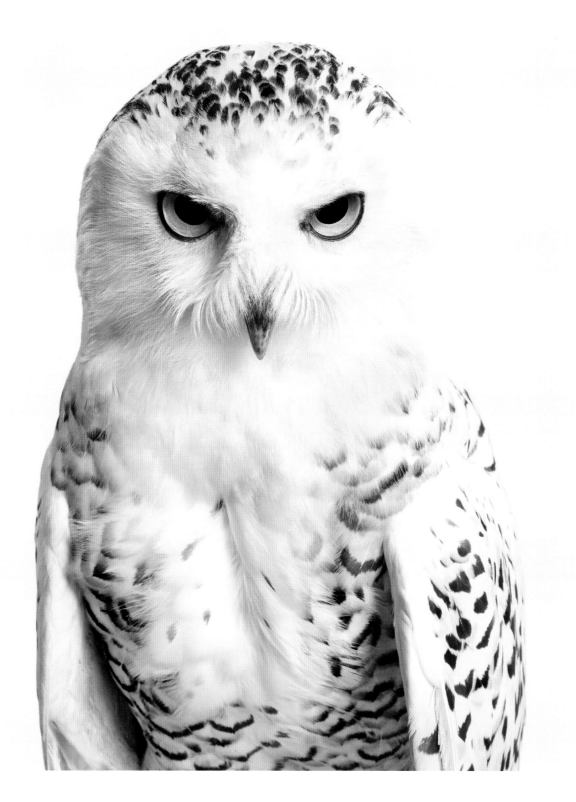

Poppy

SNOWY OWL

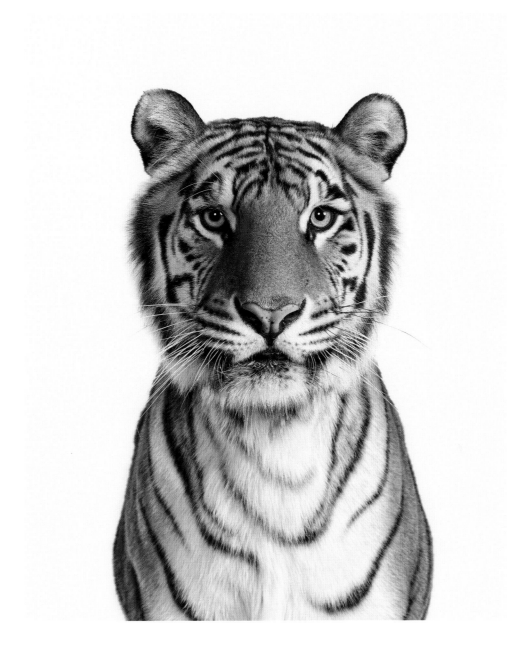

Schicka

PLATE 68

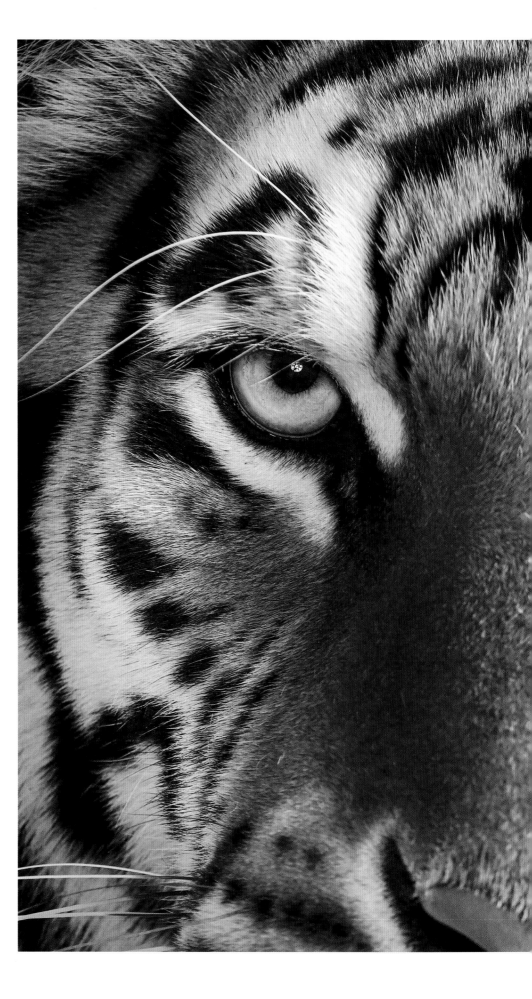

Schicka

BENGAL TIGER

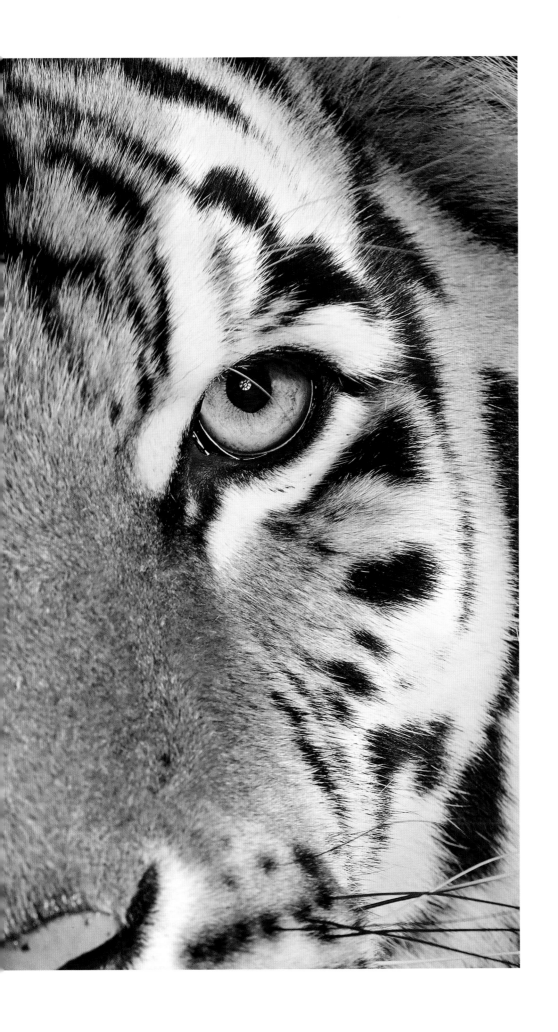

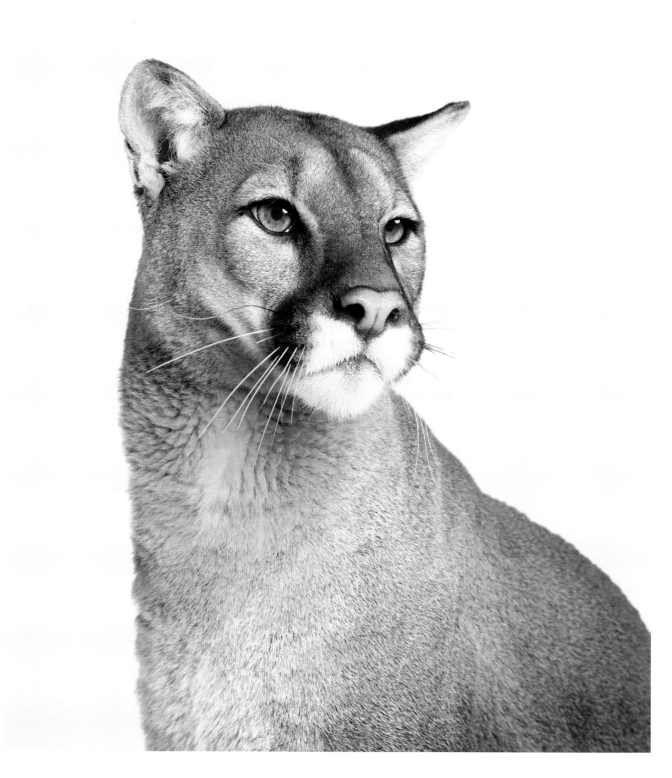

Dexter

MOUNTAIN LION

PLATE 69

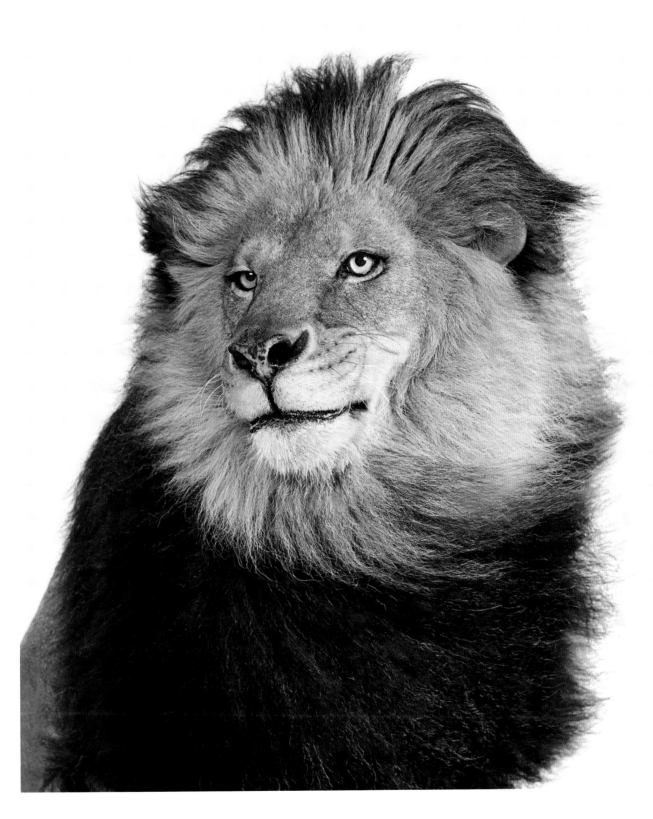

Felix

PLATE 20 LION FRAME 111/125

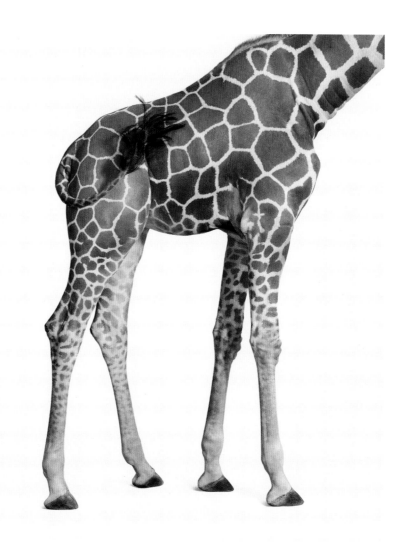

Buddy

PLATE 71

GIRAFFE

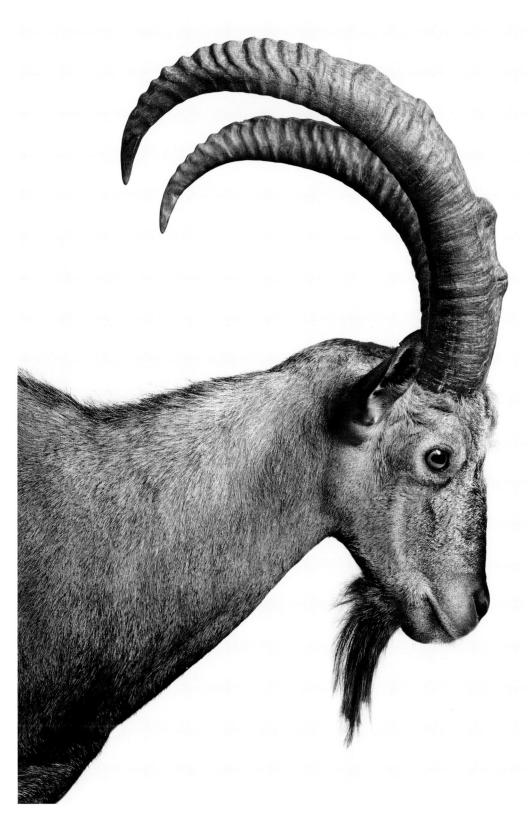

Malakeh

"MY GOAL WAS TO
SEE IF HE WOULD
POSE IN A FEW VERY
HUMAN WAYS. THIS
ONE IN PARTICULAR
WAS INSPIRED
BY THE FAMOUS
AUGUSTE RODIN'S
THE THINKER."

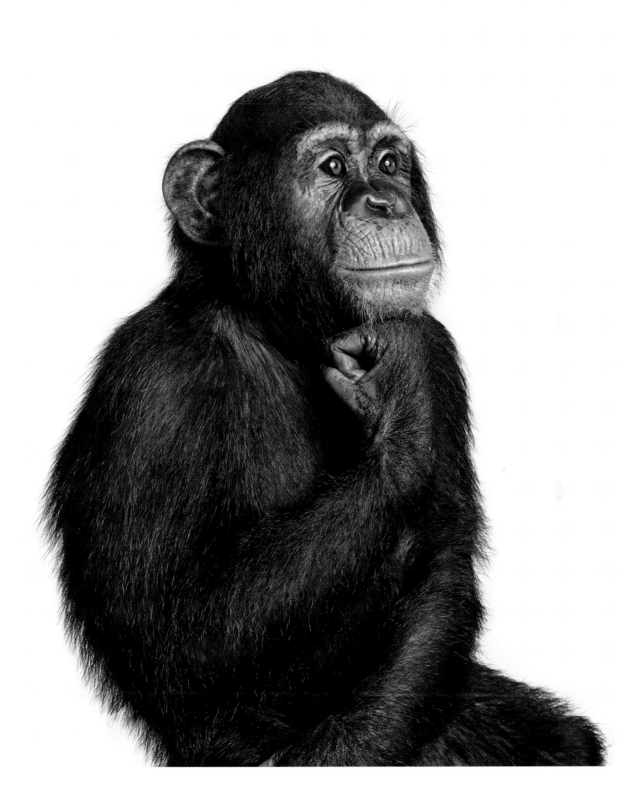

Amari

PLATE 23 CHIMPANZEE FRAME 24/96

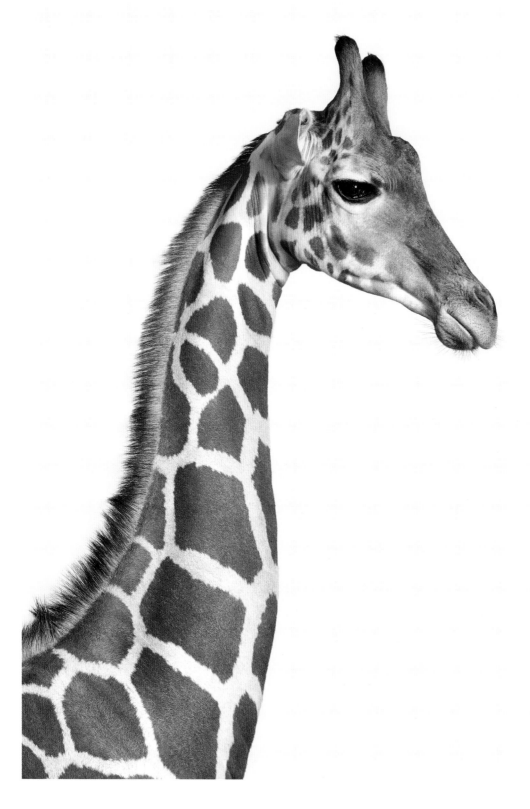

PLATE 24

Buddy

GIRAFFE

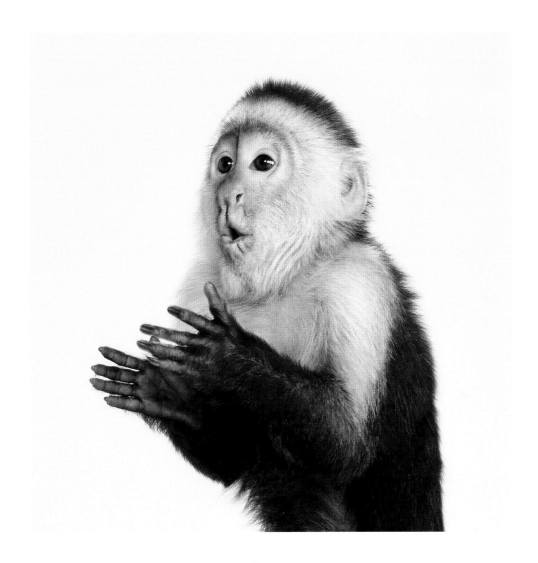

George

PLATE 35

CAPUCHIN MONKEY

PLATE 26

Sheena

SPOTTED LEOPARD

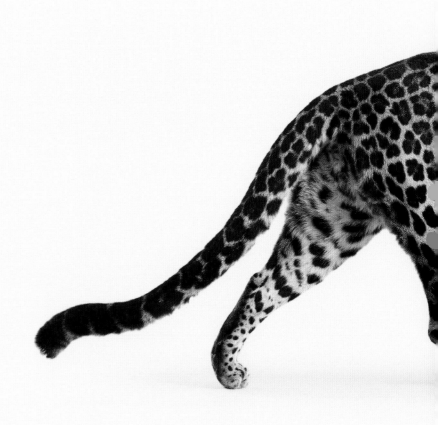

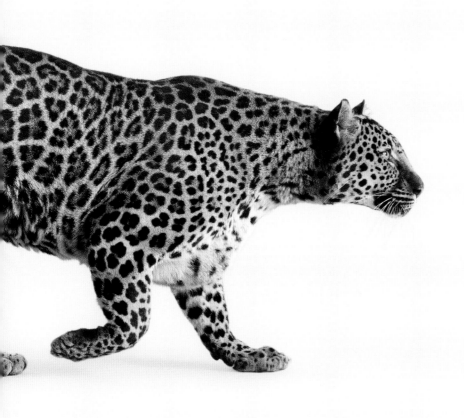

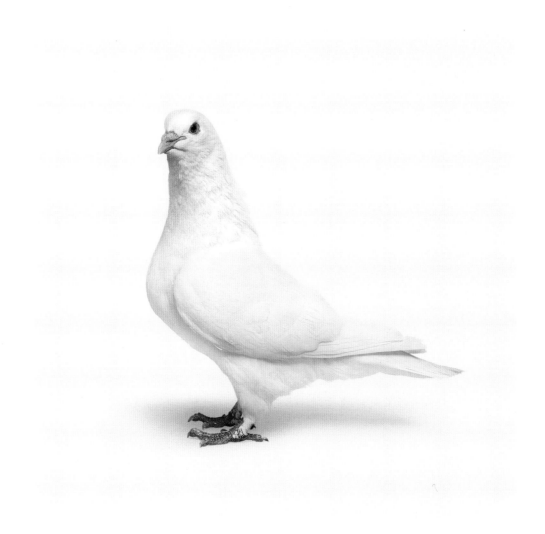

Pax

PLATE 77 HOMING PIGEON FRAME 06/11

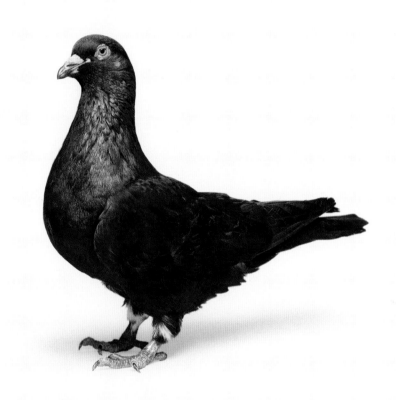

Shilo

PLATE 28

HOMING PIGEON

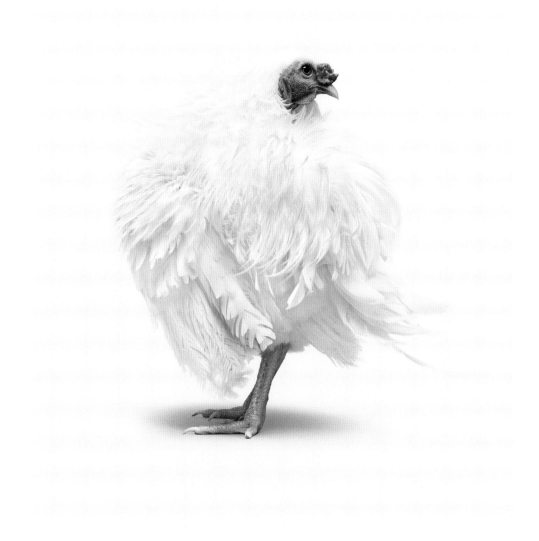

Hattie

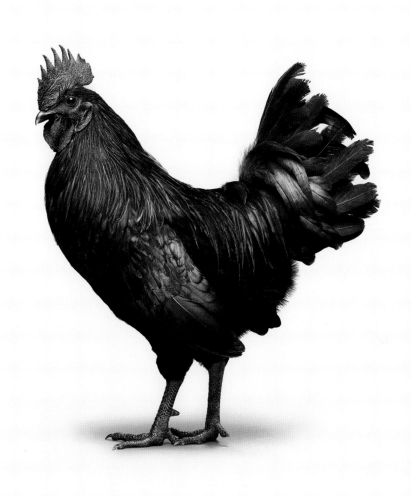

Krishna

PLATE 80

AYAM CEMANI ROOSTER

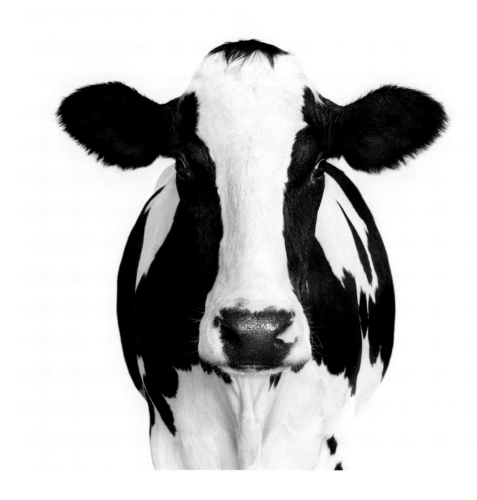

Maxine

PLATE №1 DAIRY COW FRAME 78/114

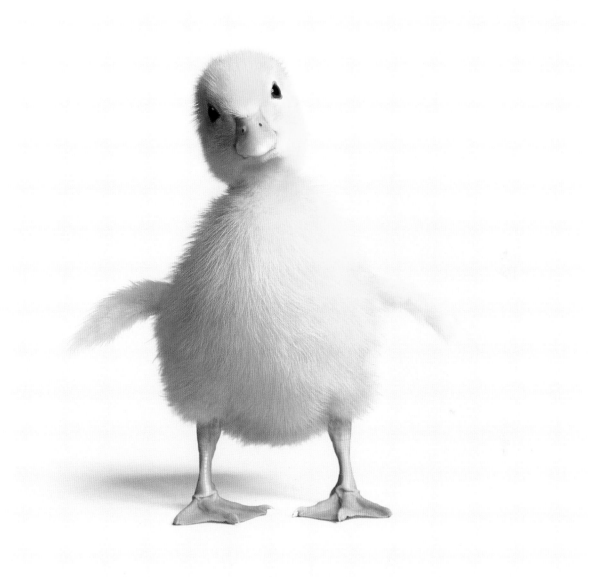

Luna

DUCKLING

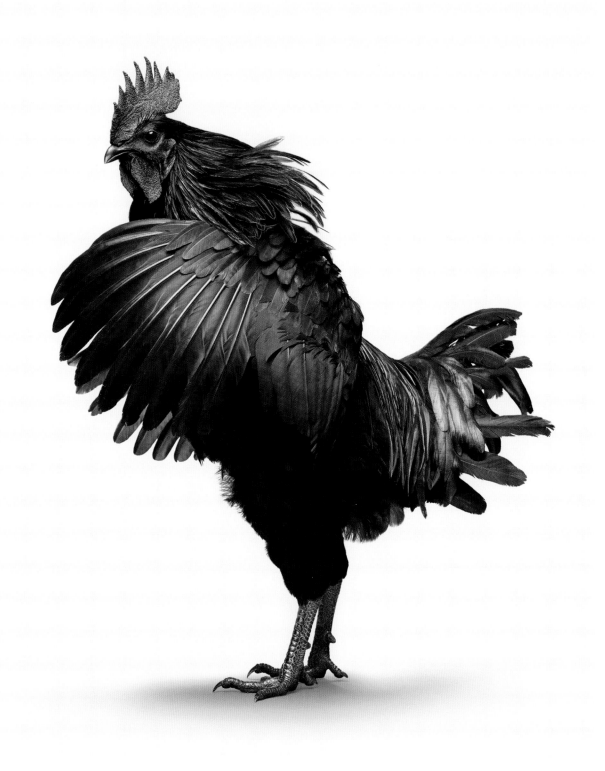

Krishna

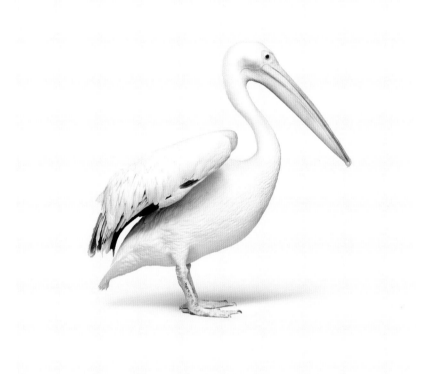

Juliet

PLATE 84 GREAT WHITE PELICAN

"MAVERICK'S
CURVACEOUS HORNS
WERE SO SYMMETRICAL
THAT WHEN I OBSERVED
HIS PROFILE, I NOTICED
THEY NOT ONLY LINED
UP PERFECTLY BUT ALSO
COVERED UP HIS EYES.
I IMMEDIATELY KNEW
THAT WAS GOING TO BE
THE SHOT TO GET."

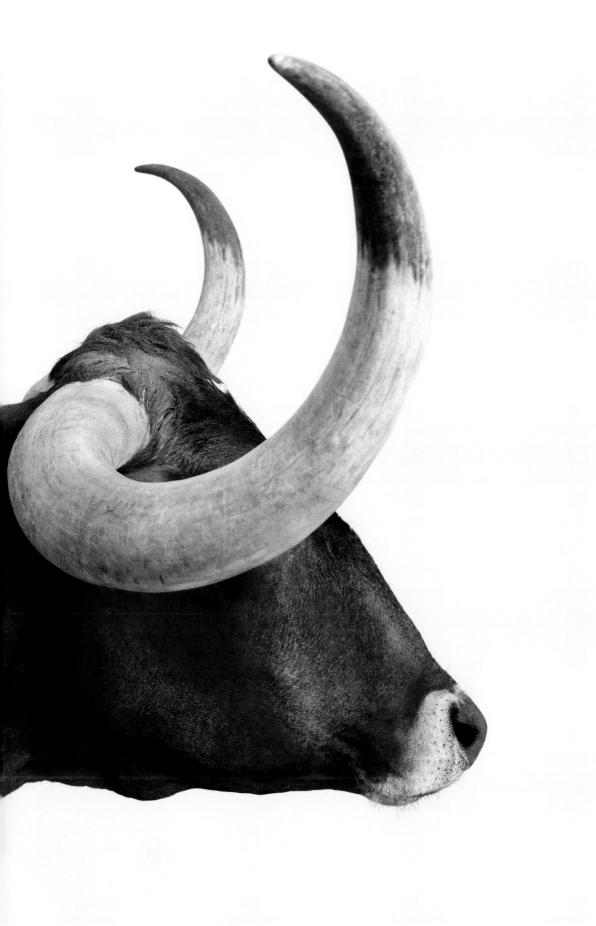

Maverick
LONGHORN

PLATE 85

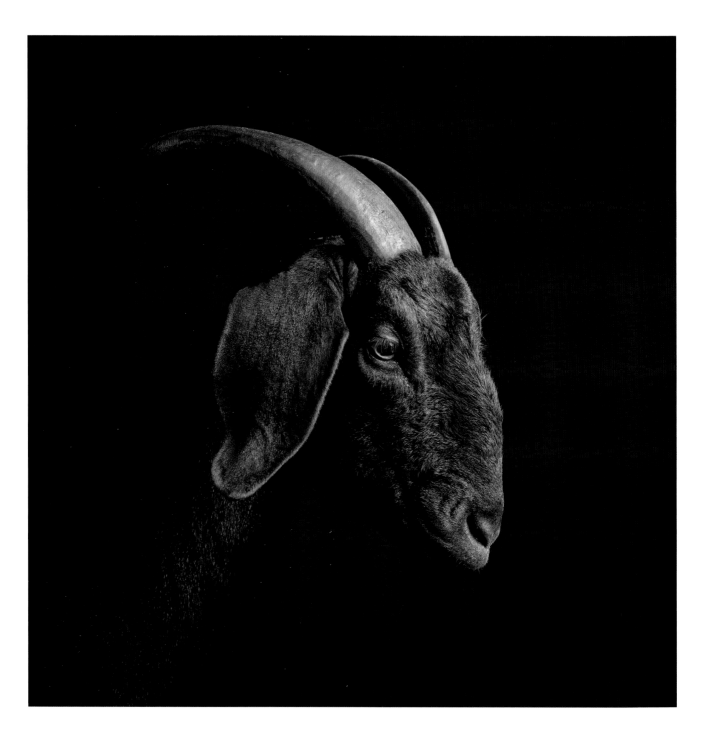

Oscuro

BLACK GOAT

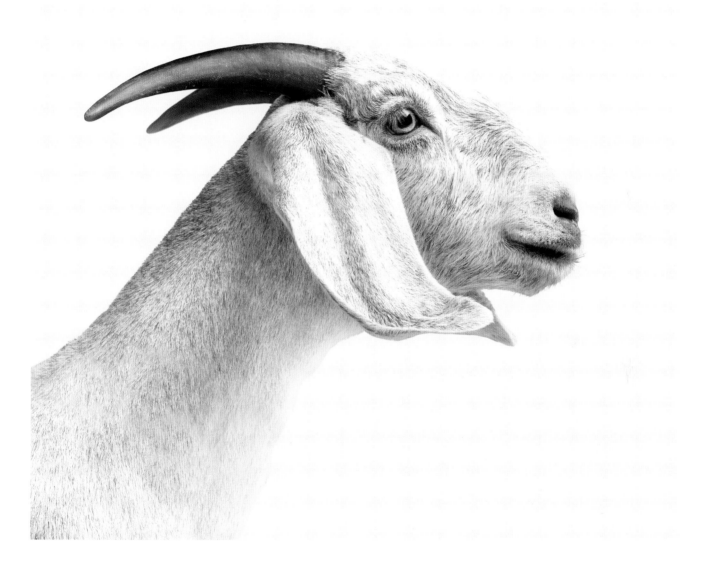

Bianca

WHITE GOAT

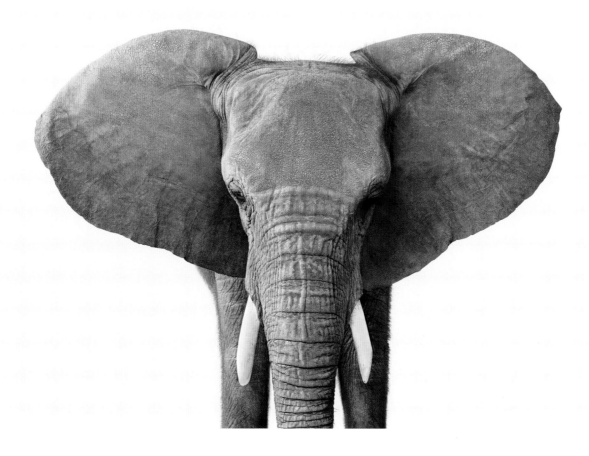

Eloise

AFRICAN ELEPHANT

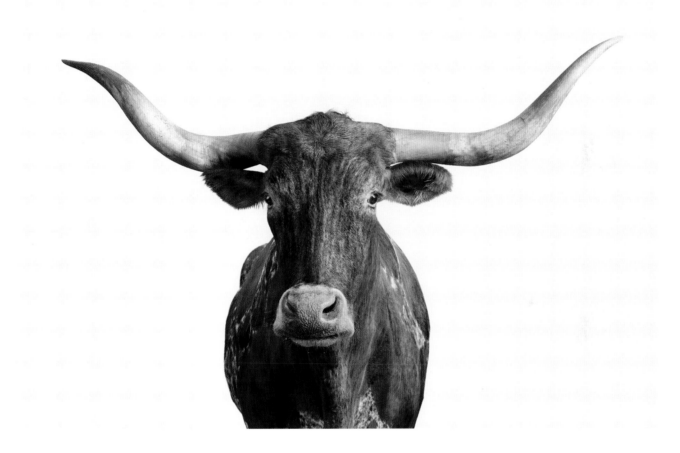

Patron

LONGHORN

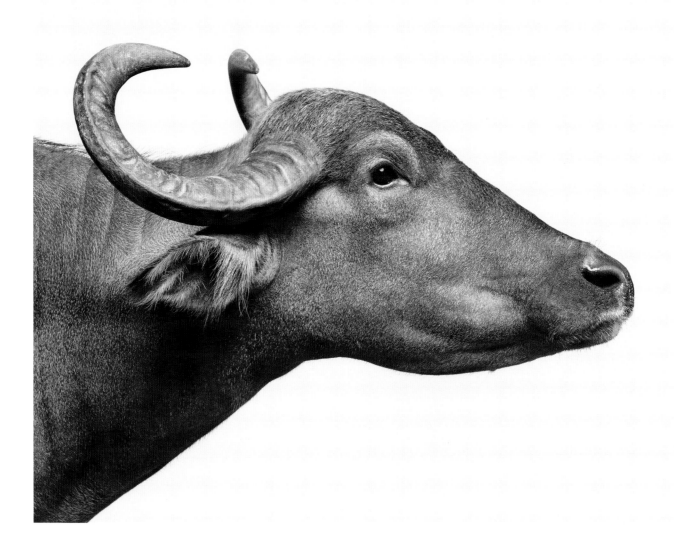

Lao Tzu

WATER BUFFALO

PLATE 20

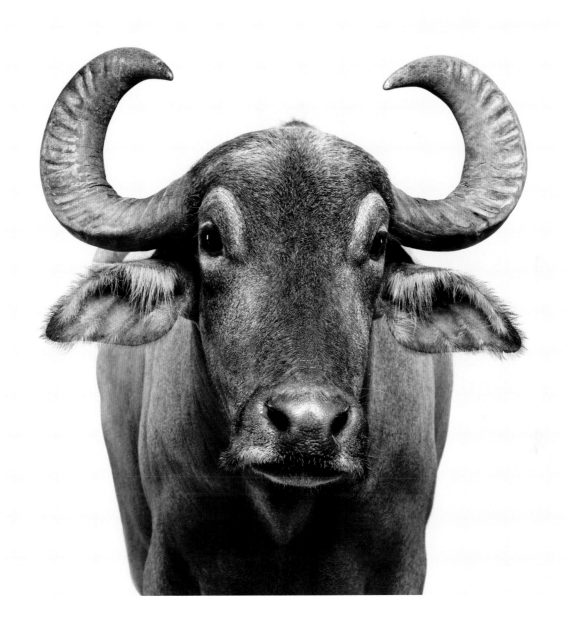

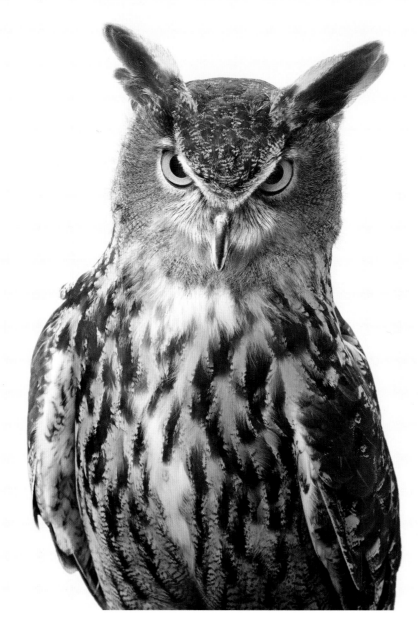

Walter

GREAT HORNED OWL

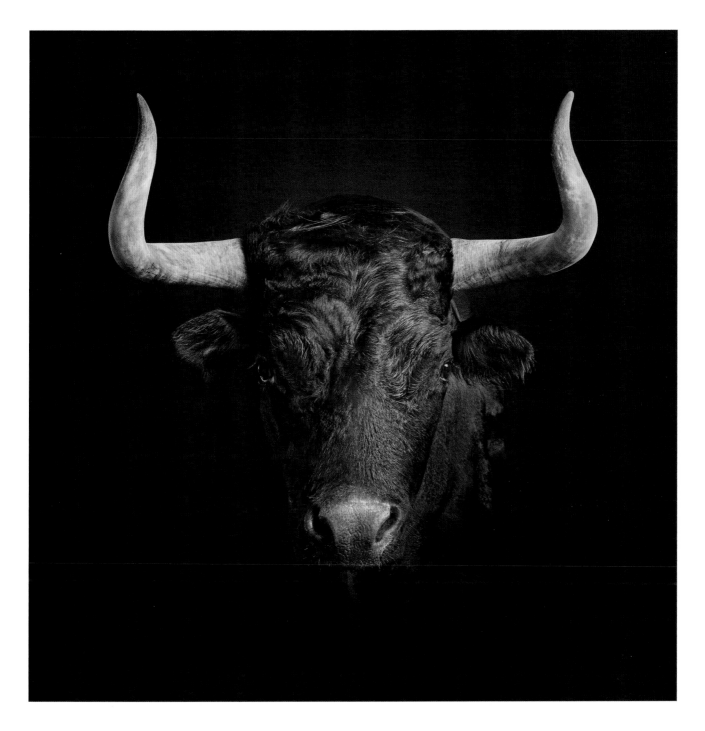

Santiago

PLATE 23

TORO BRAVO

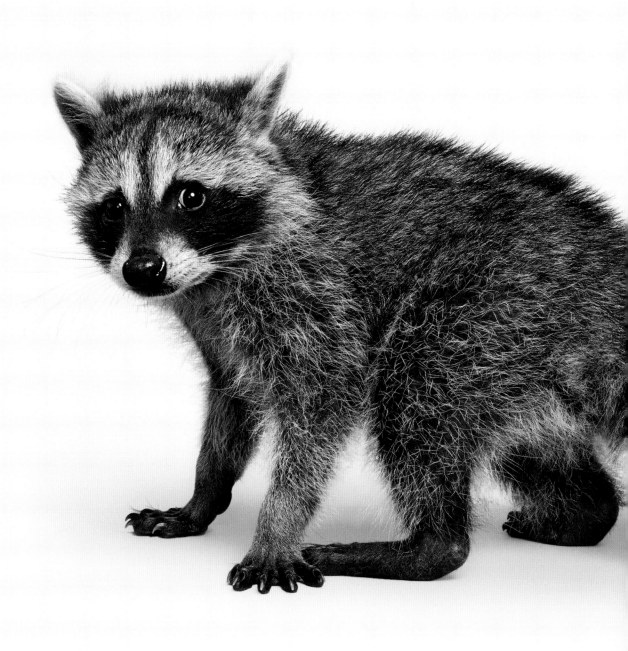

Lewis

RACCOON BABY

PLATE 94

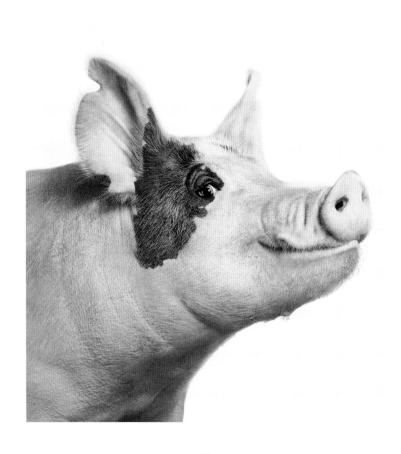

Rupert

PLATE №5 PINK PIG FRAME 45/87

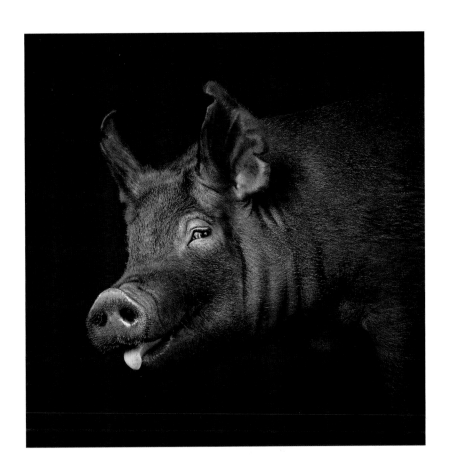

Jethro

BLACK PIG

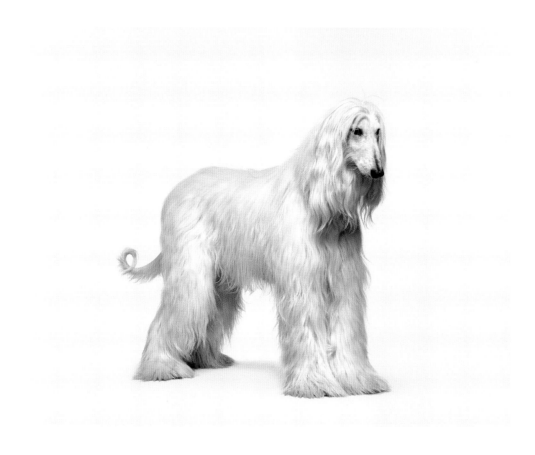

Kurt

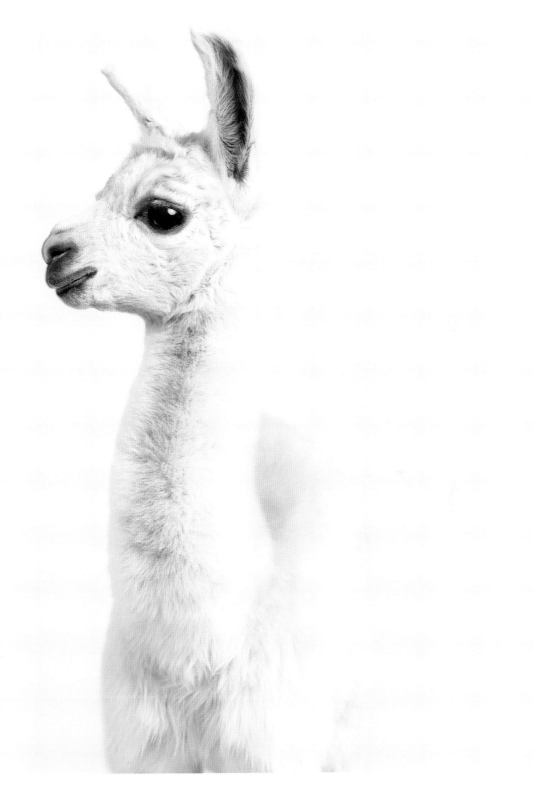

PLATE 28

Tina

LLAMA BABY

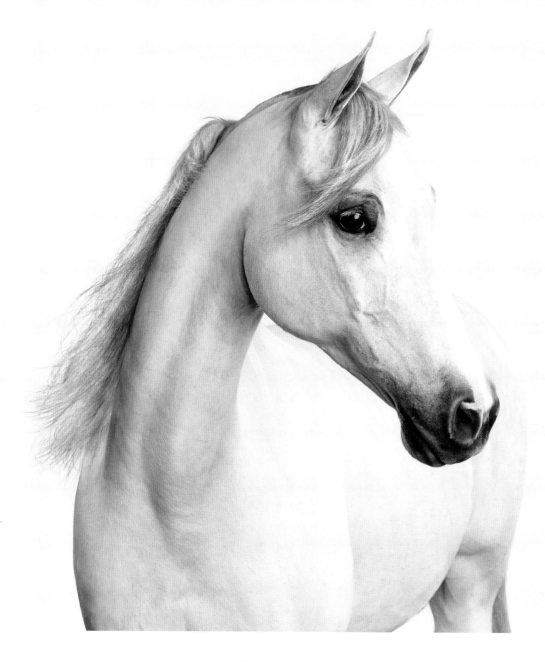

Sergeant Pepper

WHITE ARABIAN HORSE

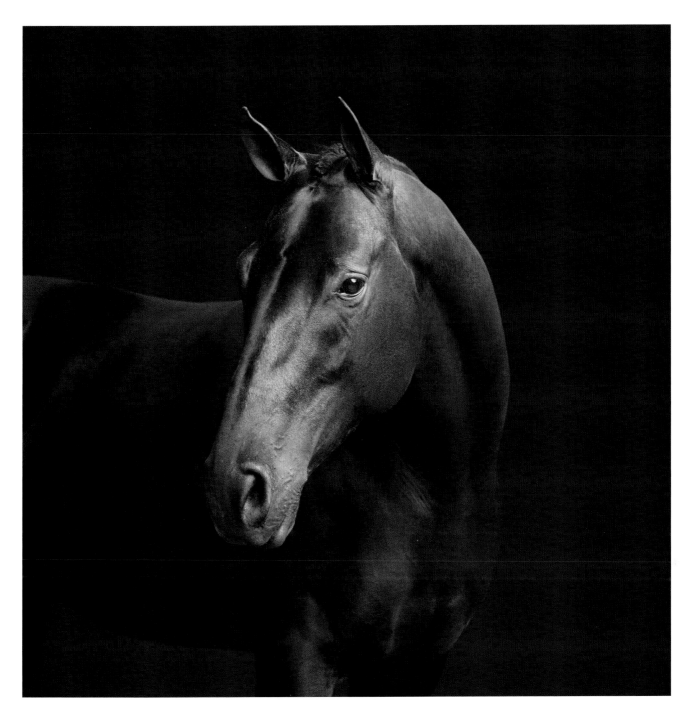

Black Betty

PLATE 100

AMERICAN QUARTER HORSE

PLATE 101

Dante

BLACK LEOPARD CUB

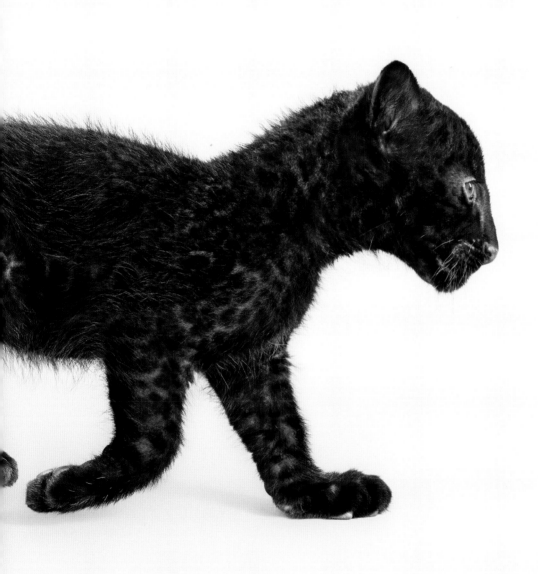

PLATE 102

Murphy
BLACK LEOPARD

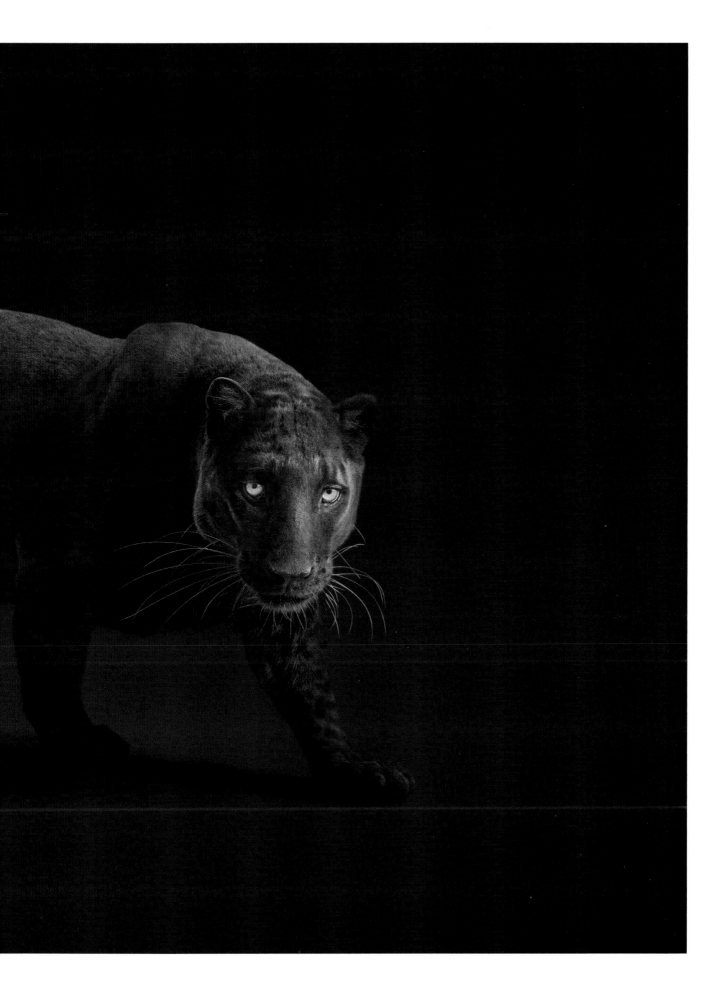

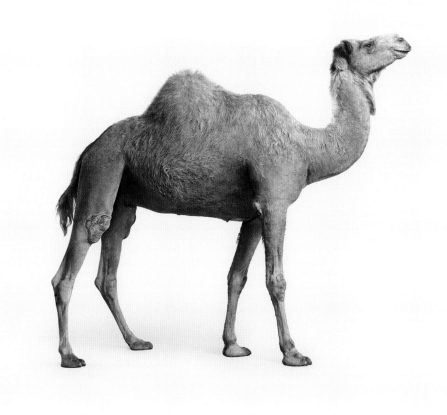

PLATE 103

Juan Carlos
DROMEDARY CAMEL

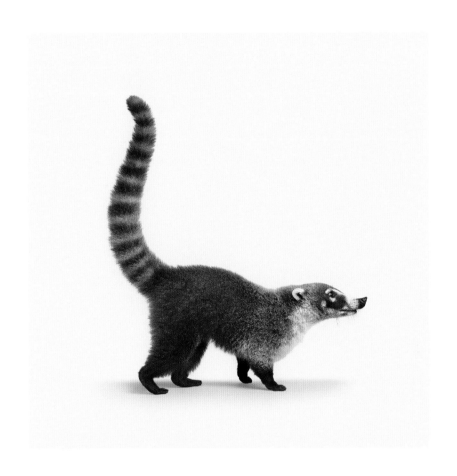

Olmec

PLATE 104

RING-TAILED COATI

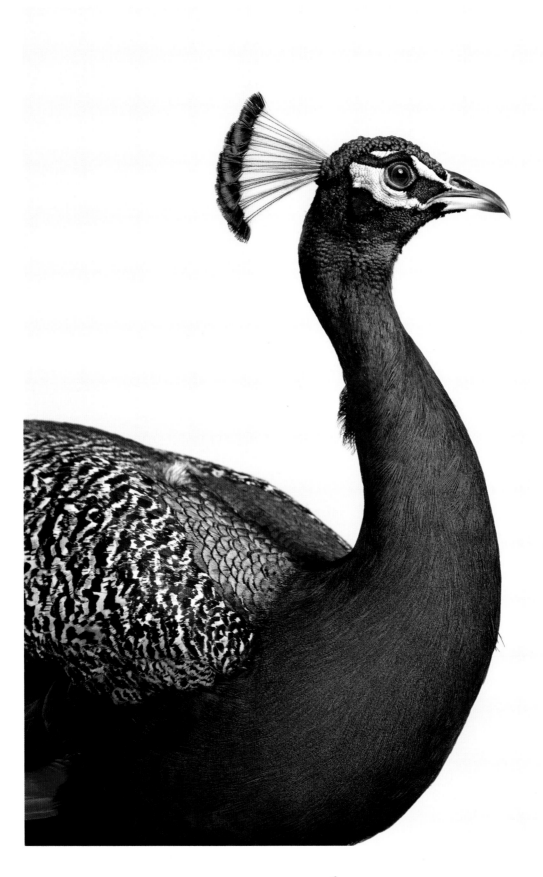

Isaac

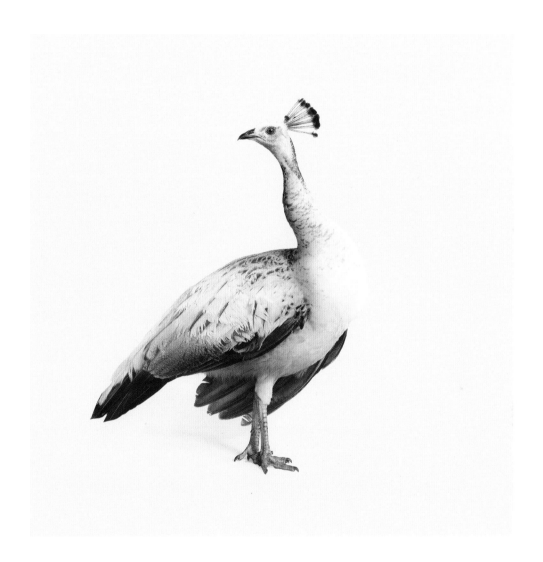

Lucy

PLATE 106

GRAY PEACOCK

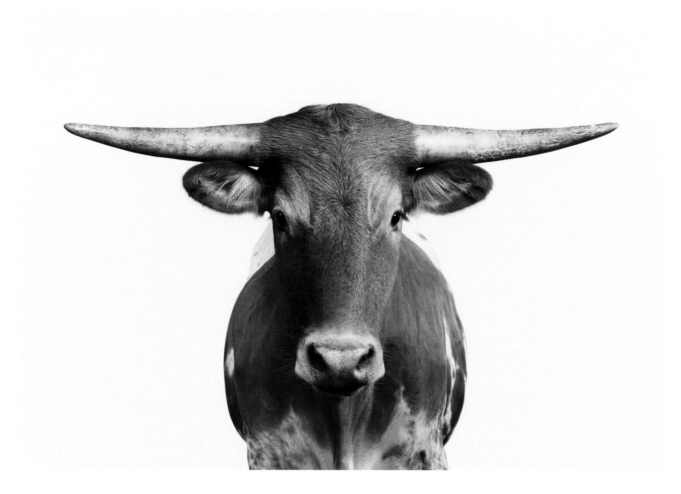

Bevo

LONGHORN

PLATE 107

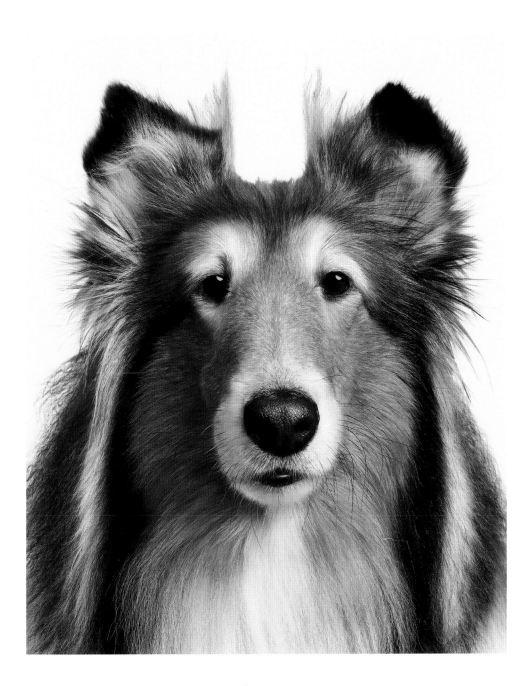

Reveille

PLATE 108

ROUGH COLLIE

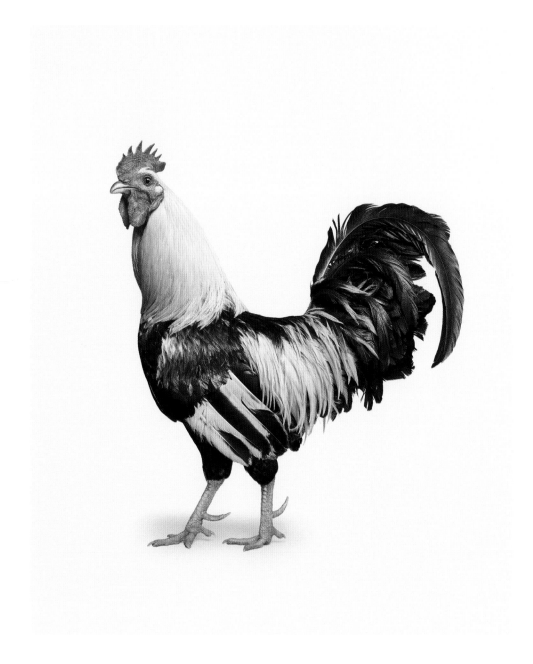

Garth

PLATE 109 AMERICANA ROOSTER FRAME 08/56

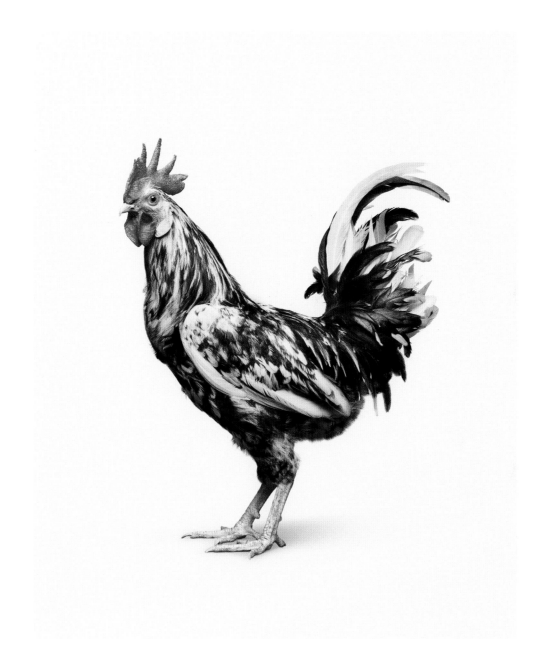

Hugo

PLATE 110

ORUST ROOSTER

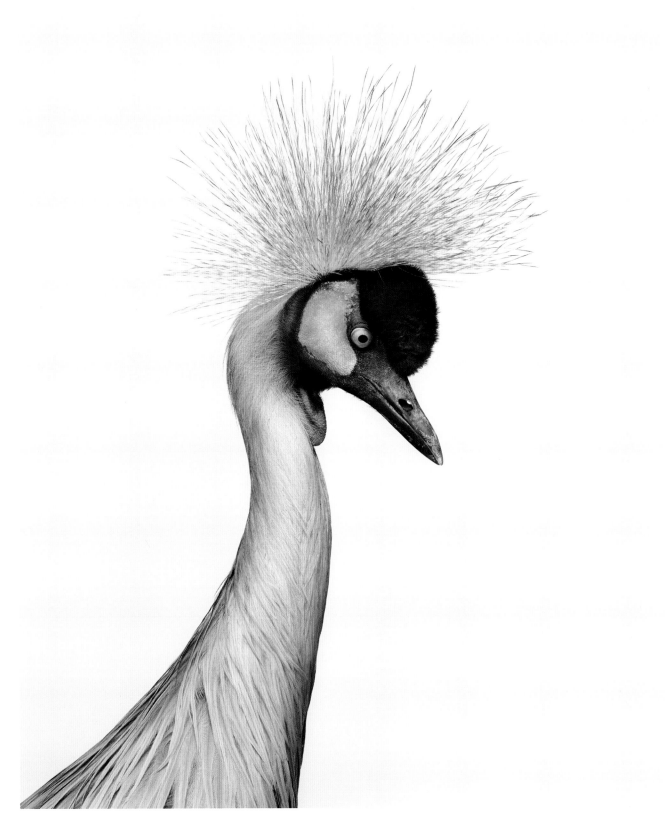

Penelope

AFRICAN CRANE

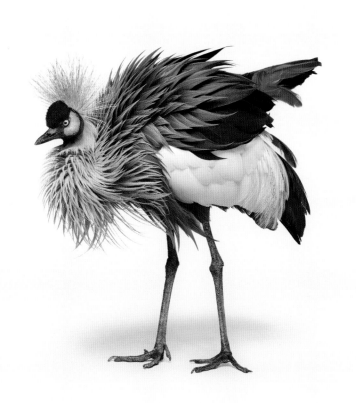

PLATE 112 FRAME 25/143

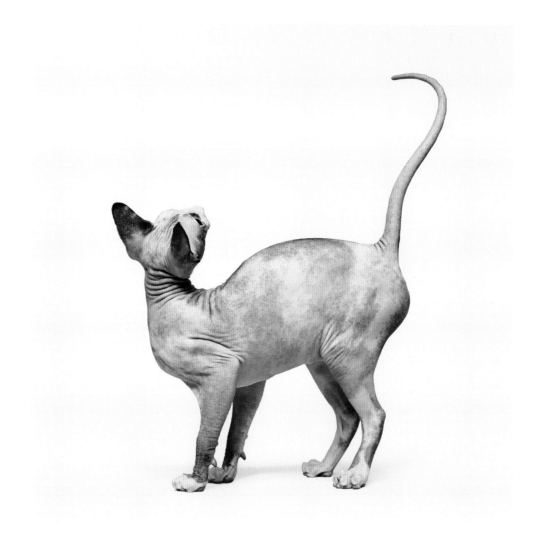

Helen

PLATE 113

SPHINX CAT

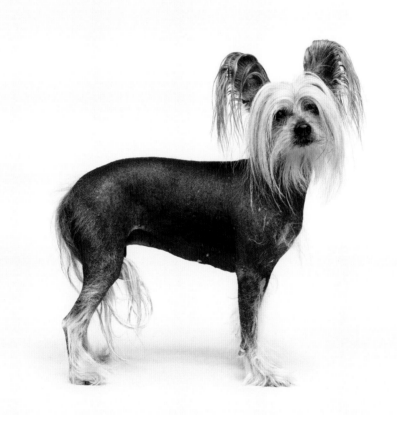

Chauncey

PLATE 114

CHINESE CRESTED DOG

"AFTER MONTHS OF EMAILING AND WEAVING THROUGH A WEB OF FRIENDS AND ANIMAL OWNERS I FOUND SOMEONE WHO HAD RESCUED BANDIT WHEN HE WAS A BABY AND HAD NURSED HIM BACK TO HEALTH. MANY ASK, DID HE SPRAY YOU... LET'S JUST SAY I DIDN'T HAVE TO TAKE A TOMATO BATH."

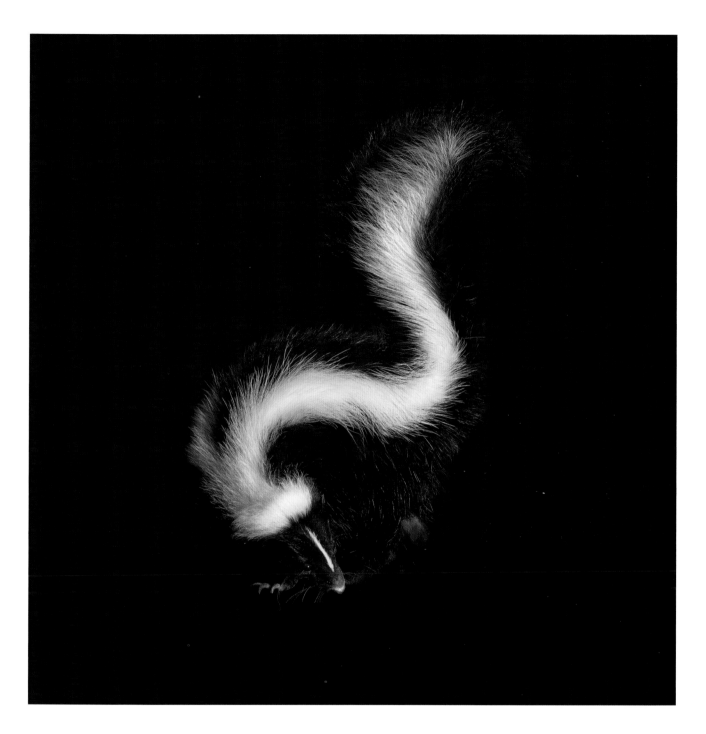

Bandit

PLATE 115

SKUNK

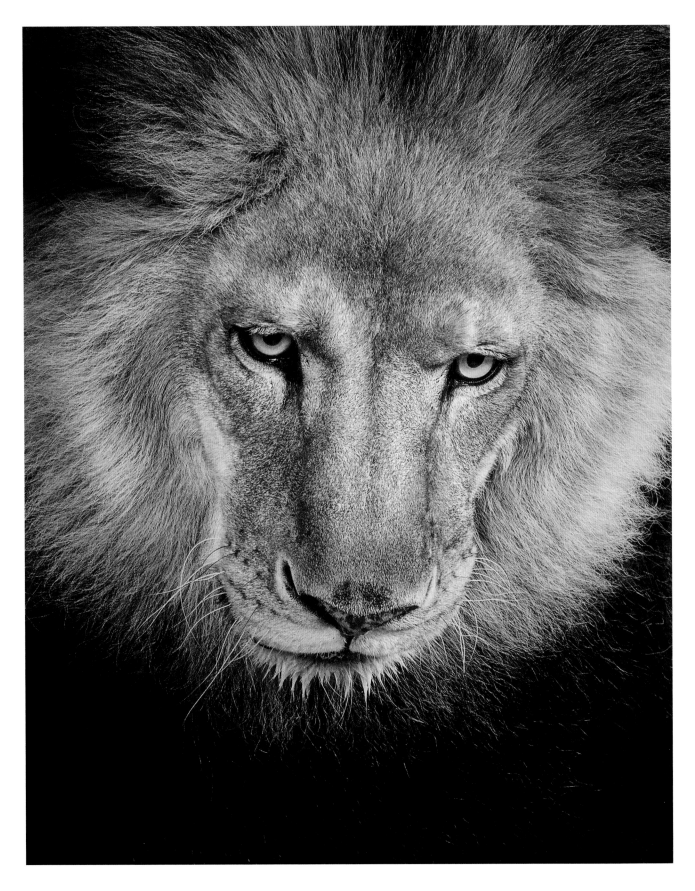

Felix

PLATE 116

LION

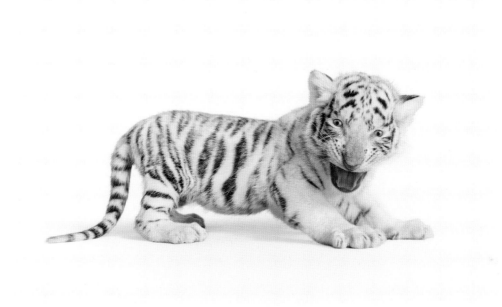

Valentino

PLATE 117

BENGAL TIGER CUB

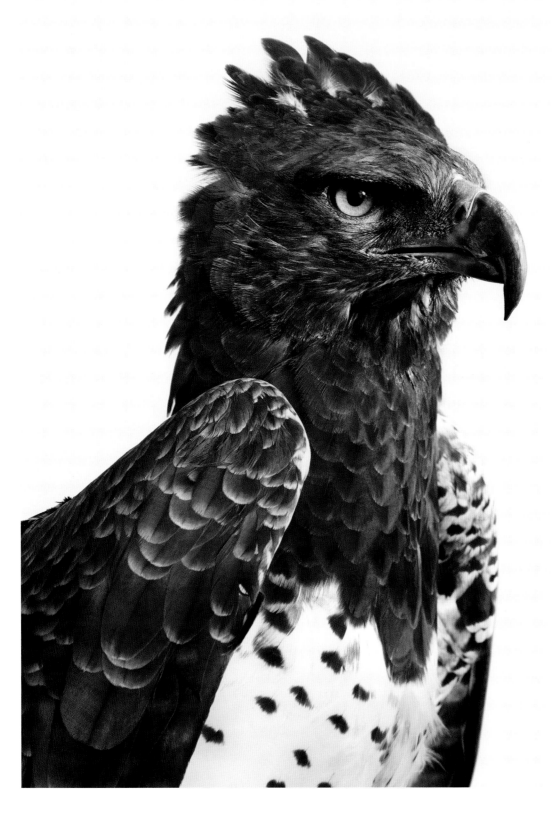

Zane

PLATE 118

MARTIAL EAGLE

"BECAUSE OF THEIR SIZE AND EYESIGHT, THEY ARE KNOWN TO PREY ON MAMMALS AS LARGE AS DEER OR ANTELOPES. FORTUNATELY FOR US, ZANE DECIDED THAT WE WEREN'T PREY AND WAS AGREEABLE WHEN POSING A FEW MINUTES FOR US."

"EXTREME COLOR
SATURATION AND ALSO
INTERACTION OF COLORS
IS PARTICULARLY
PERFECTED IN SO MANY
BIRD SPECIES. FOR
AMELIA, THE VIBRANT
COMBINATION OF PALE
PINK, WARM RED, SUNSET
ORANGE, AND PURE
WHITE COULDN'T HAVE
BEEN MORE PERFECT."

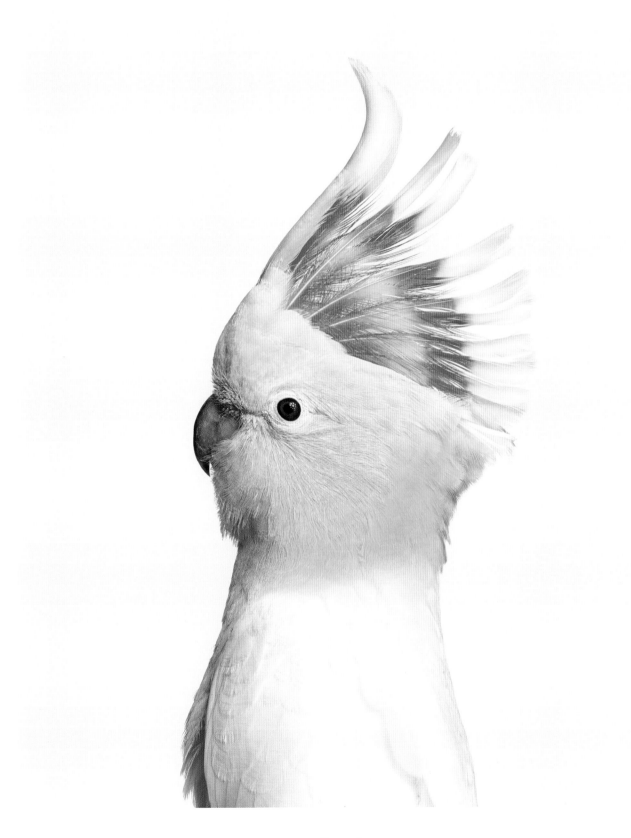

PLATE 119

Amelia

PINK COCKATOO

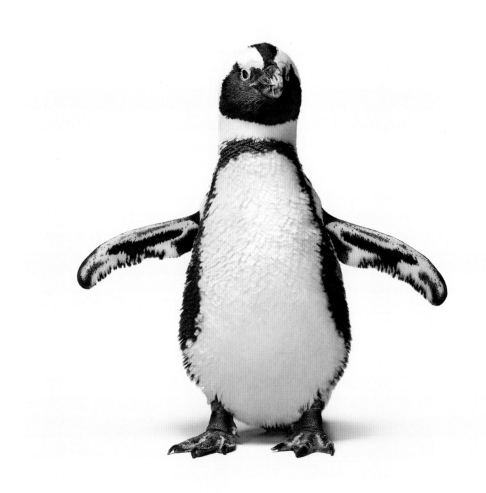

Kowalski

PLATE 120

AFRICAN PENGUIN

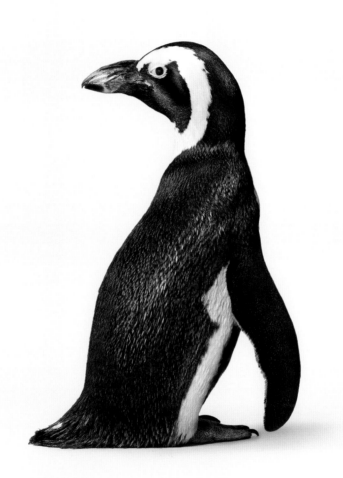

PLATE 121 FRAME 45/94

PLATE 122

Dexter

MOUNTAIN LION

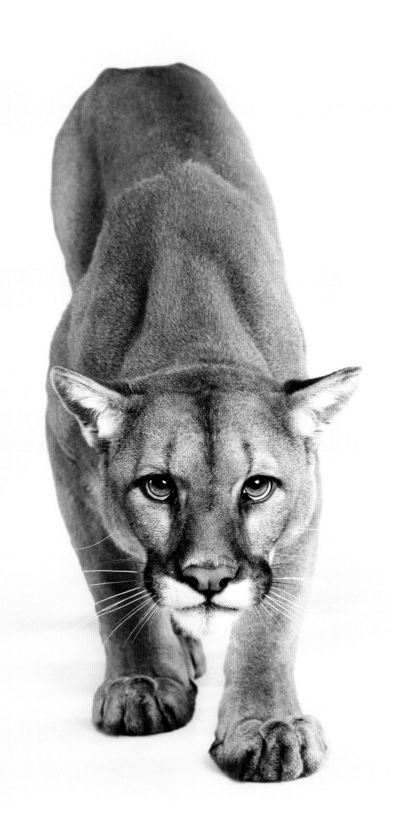

"HE JUMPED OFF THE RISER HE WAS ON AND CAME DOWN TO EAT THE CHICKEN AT MY FEET. THE FEAR INSIDE ME WAS LITERALLY LIKE A RUSHING WAVE DROWNING ME. BUT I KNEW DAMN WELL NOT TO MOVE."

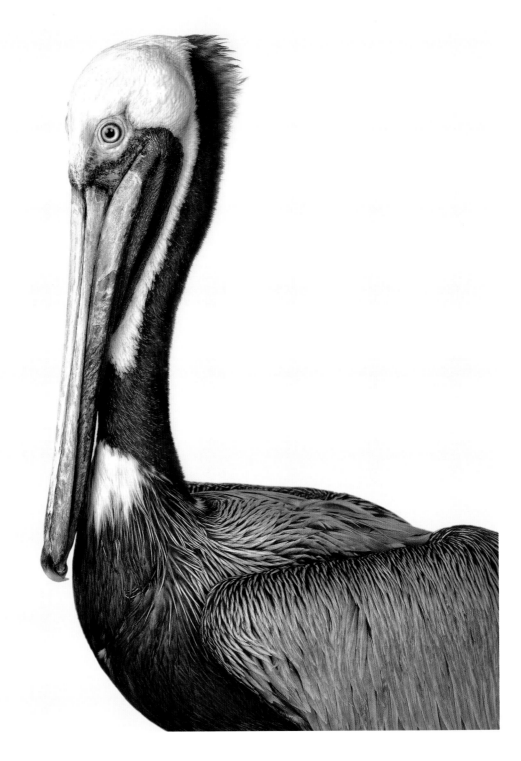

PLATE 123

Alfonzo

BROWN PELICAN

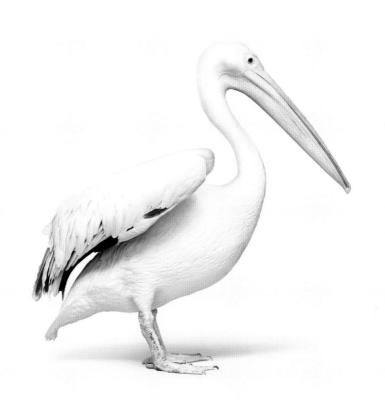

Juliet

PLATE 124

GREAT WHITE PELICAN

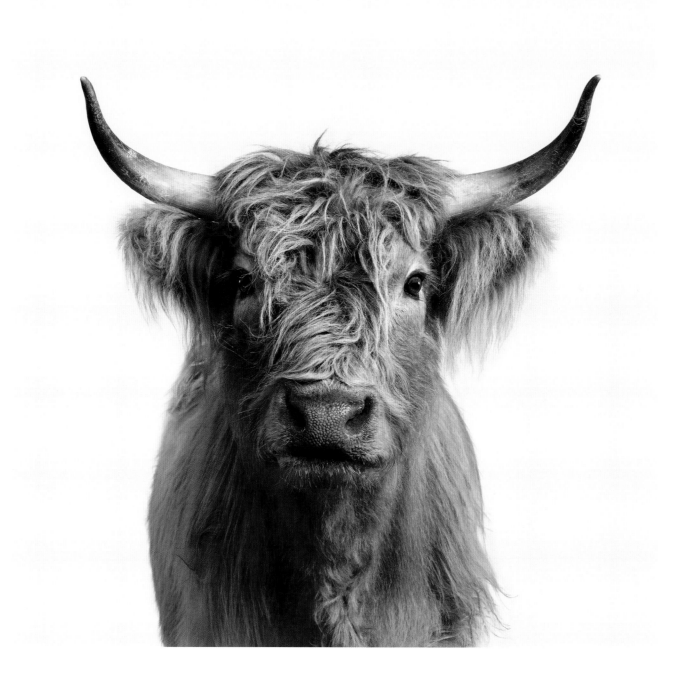

Eleanor

PLATE 125 HIGHLAND COW FRAME 75/83

"ELEANOR, THE
PERFECT EXAMPLE
THAT IMPERFECT CAN
BE OH-SO-PERFECT."

PLATE 126

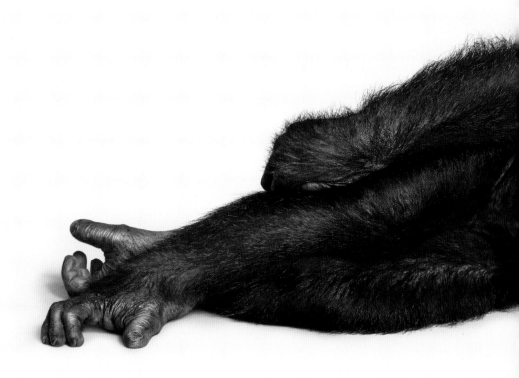

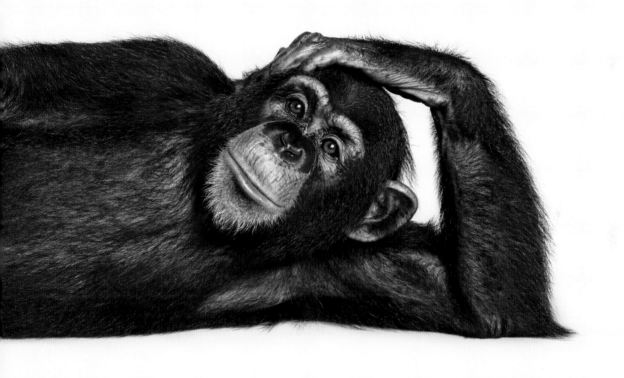

"BEING IN A STUDIO WITH
A BIG CAT OFF LEASH IS AN
INCREDIBLE EXPERIENCE.
THE SIZE AND PRESENCE
OF A BIG CAT IS TANGIBLE,
SO POWERFUL, AND
COMMANDS RESPECT. TIME
FLIES, BUT AT THE SAME
TIME, STANDS STILL."

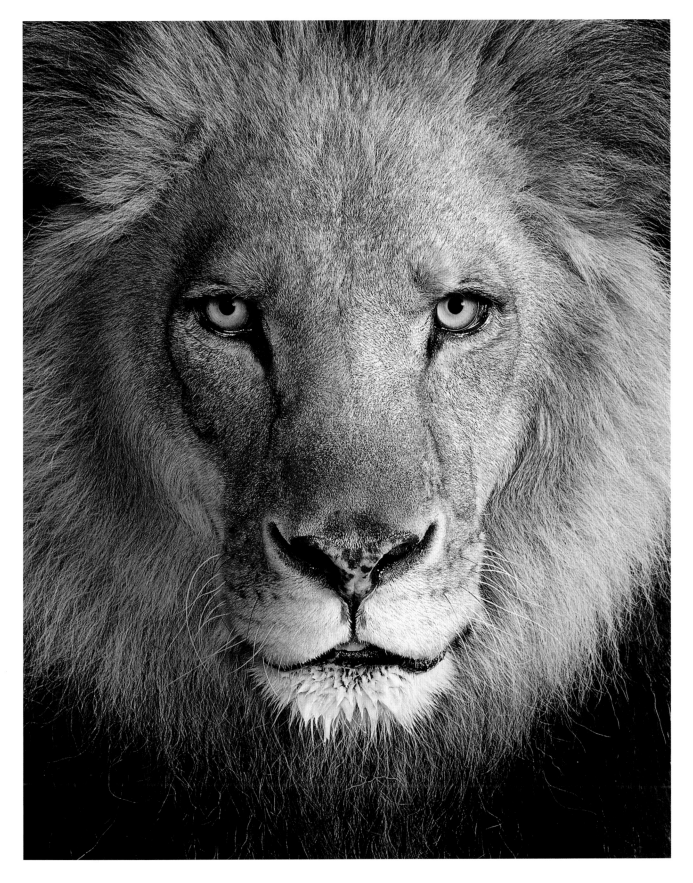

Felix

PLATE 127 LION FRAME 88/125

ACKNOWLEDGMENTS

I COULDN'T PRODUCE the images I'm able to capture without the collaboration of the dedicated animal lovers that I have had the privilege of working with. I also couldn't do it without the hardworking photo assistants and producers I work with throughout this process. The final step in the creation of these photographs is retouching, and I am grateful to Amber Politi for all of her help digitally cleaning up the backgrounds and animals so that they look their absolute best.

I am grateful to DJ Stout of Pentagram Design. 10 Years ago, the renowned designer first hired me to photograph a series of dairy cow portraits. That cold and rainy day inside a barn in the middle of Texas was the inception of this animal portrait collection. The image of Shirley, opposite this page, was a highlight from that shoot. Thank you to Carla Delgado of Pentagram Design who has spent countless hours with my work and the design of this book. And thank you to the publishing team at Rizzoli New York who saw the uniqueness and potential of my animal portrait collection.

A small selection of the images in this book were commissioned by advertising and design agencies. These creative collaborations resulted in some of the most unique animal portraits and for that I am sincerely grateful.

Thank you to my good friend Jared Dunten who helped me craft and refine the stories for each animal. An artist himself, Jared is an inspiration to me, and I couldn't have personified these beautiful creatures without his help.

Thank you to my family. My wife Lauren, who has supported me along the way, patiently offering her honest opinions, valuable feedback, and unconditional love. My kids, Layla, Ellis, and Everett, who have taught me more than I could ever dream of learning. To my first photography teacher and grandfather, Creed Ford Sr. And, finally, to my parents who never hesitated to say "yes" when I told them I was going to be a photographer. Their encouragement along the way has been pivotal in my journey.

Most importantly, without the amazing work of divine Mother Nature, I wouldn't have such interesting and beautiful subjects to connect with. Despite having photographed over 100 animals up close and in person, I still marvel at the beauty of God's animal kingdom.

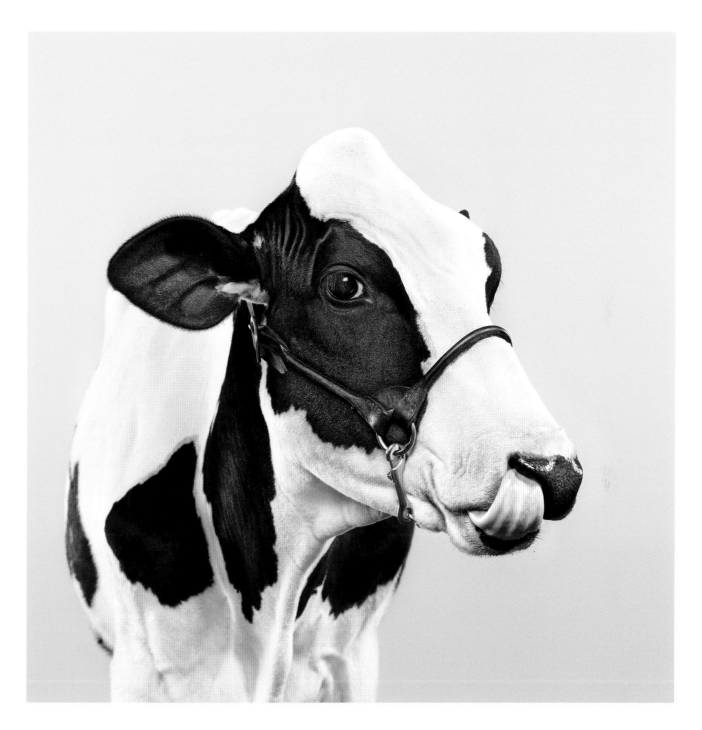

Shirley

DAIRY COW

PLATE 128

PROCESS NOTES

A PORTRAIT IS A collaboration between subject and artist. These are no different. I am working with the animal itself and typically the animal's owner or trainer. Without collaboration from subjects on both sides of the camera, it would be impossible to create these unique portraits.

My process starts with photographing the animal in a studio and crafting lighting that is simple but executed exceptionally well. The backgrounds in my portraits are a neutral color that compliments the animal without being distracting.

During the shooting process, it's not uncommon that an animal gives you just a glimpse of its personality. My need to stay on point and focused is imperative in capturing that split second when an animal reveals itself.

To finish the process, I apply a simple treatment of dodging and burning to the image in postproduction. These subtle adjustments to color and contrast allow me to further push the image to a place that is tactile while at the same time soft and aesthetically pleasing.

And, of course, these are animals. We love them, we respect them, but we cannot control them. It's up to them to decide the story being told. And at the end of the day, if the photo gods shine down upon us then we get to see just a brief glimpse into their soul.

INDEX OF STORIES

EVERY ANIMAL I'VE PHOTOGRAPHED has a story behind the shoot. Some animals are challenging, some are entertaining. In the words of Dr. Seuss, some have "scared me right out of my pants." The following pages are a glimpse behind the scenes of my experience working with these creatures. I hope they give you an entertaining and anthropomorphic look at the uniqueness behind each portrait and a taste of each animal's individual personality.

INDEX

 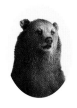 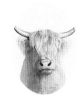 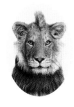 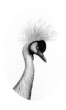 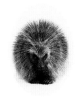 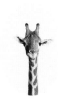 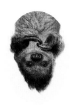

№1
Geronimo
BLACK WOLF

Geronimo was no dog. I love dogs and am around them all the time. And when I see pictures of wolves, I associate them with dogs. But when I saw Geronimo in person, I knew instantly he was a wolf and not a dog. The way wolves move and their sleek figure are instant giveaways. I could tell he was more predatorial, more primal, and more instinctual than any dog. Wolves don't walk, they prance. And Geronimo did just that. He danced around the studio, sniffing us all briefly and posed for us for only a few minutes, and then he was ready to leave.

№2
Bam Bam
GRIZZLY BEAR

Bam Bam was a rock star. He is a celebrity animal and has appeared in many commercials and movies. Like other bears, he loves his sweets and enjoyed honey and pastries on set. With large predators like bears, I always work with trainers that are not only safe but also love and respect their animals. It was clear that Bam Bam and his owner have a great relationship, and you can sense the mutual trust and respect.

№3
Gertrude
HIGHLAND COW

What a Gertrude. Similar to a yak, Highland cows have long, beautiful, shaggy hair. Per their name, they are originally from the Highlands of Scotland. Most Highlands are redheads, but Gertrude was a blonde beauty. I loved how her locks covered up her eyes, and in this frame, she tilted her head slightly as if she was telling me something. My affinity for cows definitely holds true with these beautiful Highlands, and this portrait of pretty Gertrude is hanging in my house.

№4
Jabari
YOUNG LION

Jabari, bedhead, messy teenager. Part of the interest of this shot is that he has a young mane growing in. This is so indicative of a teenager, which I guess in Lion-years, Jabari was right on schedule. The messiness, the awkwardness, and the length of his mane all cue the audience to his age and demeanor. Like a teenager, he was all over the place when we photographed him. Some animals sit still for me, and I can capture plenty of images. But Jabari only sat still a few times, and I only captured a few decent shots. His size was small enough to know he was young but still big enough to intimidate me as an observer.

№5 №11 №12
Penelope
AFRICAN CRANE

Penelope liked to dance, but once the lights came on she owned the shoot. Birds are one of my favorite subjects and Penelope had the whole crew's attention with her elegance and majesty. I wanted to show different tones of gray and also the textures of her feathers so I highlighted her with directional lighting. She was truly a royal subject.

№6
Nora
NORTH AMERICAN PORCUPINE

Nora moved very slowly, which is good when trying to create an interesting portrait. But, she was very small and her head so close to the ground that we had to raise Nora up on a couple risers four feet off the ground, which allowed me to get the camera on his eye level. From there, it was all about trying to create a portrait that showed off the symmetry, his face, form, and texture. I loved how his quills frame that mug.

№7 №1 №4
Buddy
GIRAFFE

Buddy was born a twin, which is extremely rare for giraffes, so, consequently, a person had to bottle-feed Buddy as a baby to make sure he received the proper nutrition. Because of this, he grew up with so much attention and became very comfortable with people. As you can imagine, he also became very popular. Buddy was sweet and a delight to work with on set, and his loving owners are heavily involved in giraffe conservation and education.

№8
Perry
TWO-TOED SLOTH

Oh boy, who would have thought a Sloth would be so challenging? Perry, which is short for Perezoso ("lazy" in Spanish), was a character. Most of my subjects can either stand on their legs or sit upright. Sloths, on the other hand, do neither. They lay or they hang—that's it. It was impossible to create a shot of Perry laying because he just melted into the floor. However, once I saw him hang, the light bulb went off: THAT was the shot. Despite his namesake, he moved constantly, literally spinning, which made it super challenging for me to capture just the right moment. After working patiently with him, I laughed at the irony of my hyperactive sloth and finally captured a shot I was happy with.

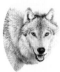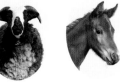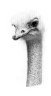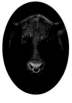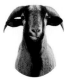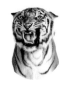

09

Jagger

GREY TIMBER
WOLF

Jagger was leader-of-the-pack. I knew instantly he was an alpha. Just like Geronimo, he danced around the studio, sniffing us all briefly, and posed for us for only a few minutes, and then he was ready to leave.

10 32

Moses

JACOB SHEEP

Let it grow, Moses. I had the chance to photograph him just before his annual sheering. His heavy, pie-bald, wool coat was long and, I assume, very hot. Consequently, Moses really enjoyed the cool air conditioning and refreshing beverages in the studio that day. The Jacob sheep takes its name from the story told in the *Old Testament* of how Jacob became a selective breeder of piebald sheep. No one knows ex-actly how old Mo-ses is, but based on his namesake, I assume he'll live to be around 120 (in sheep's years of course).

11 44

Weston

FOAL

There are few things more ador-able than a baby horse. Twenty-eight-day-old Weston and his ridiculously cute gallop would make even the manliest of men soften and belt out... "aww-ww." Since he was a foal, we didn't want to keep him away from his Mama long so our shoot was fast, but with a babe this cute you really can't take a bad picture.

12

Catalina

OSTRICH

Catalina made me just as nervous as some big cats. But sometimes you get one frame with just the right pose. And I con-sider myself lucky to have captured Catalina in this pose. We had limited time with her because, well, she's not only a big bird but also a fast one. And ostriches can be very dangerous. Although they are considered prey to big cats, their defense mechanism is to raise their mas-sive talons and kick the hell out of a predator. In order to keep her safe and us safe, Catalina's trainers brought in a 20x20 metal fencing to set a perimeter around her. As we shot, the trainers would open and close the fence.

13

Wayne Crosby

BLACK BULL

Wayne Crosby fit us in his schedule. If it's not obvious, cows are one of my favorite subjects. And this portrait of the cantankerous Wayne Crosby was my first in the series of the black collection and still remains well in demand. Some animals I prefer to be pristine and clean, others I prefer natural to their environment. Prior to the shoot, Wayne Crosby spent time in the pasture kicking up dust, chomping on hay, and chasing after some pretty little heifers. We created a mobile set in the big red barn and were able to capture a handful of frames before he ran out on us. Dairy cows, steers, and heifers are usually docile. Bulls, not so much.

14

Eva

LEOPARD
APPALOOSA
HORSE

The second I saw Eva, I knew I had to create a por-trait of her. Her classic leopard appaloosa spots were captivating to me. The greatest perfection is in imperfection. What a beauty. Her demeanor was strong but serene. If I ever have the chance to own a horse, a Leopard Appaloosa would be my pick.

15

Octavius

BARBADOS
BLACKBELLY
SHEEP

Octavius was vocal, to put it mildly. My experience with goats and sheep has always been wonderful, but the one thing worth noting is how loud a sheep "bah" really is. Especially in the studio. It's piercing, to be honest. I love the shape of his horns and black stripes on his face and neck. But the pièce de résistance is the crooked smile Octavius gave me for this one frame. What's his emotion? You decide.

16 19 67 68

Schicka

BENGAL
TIGER

Schicka was my first large cat to photograph in-studio. Large cats in the studio are an experience unlike anything else. The combination of power and grace is tangible. They command respect, and one wrong move can make things escalate quickly. I remember distinctly when Schicka's trainers removed her leash and asked her to walk to the mark. The way she walked was so graceful and stunningly beautiful. But I was in the middle, at her mercy. The feeling that I could be prey was chilling. She received fresh, uncooked meat as her reward between takes. I only work with trainers who show a great amount of respect for the animals and are incredibly thoughtful with their care. Schicka's owners not only treat her with dignity but also love. It was obvious there's an ongoing relationship of trust and appreciation.

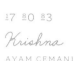

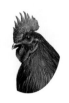
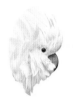
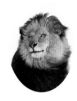
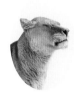
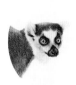
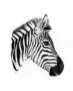

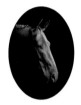

17 80 83

Krishna

AYAM CEMANI
ROOSTER

Krishna is real. No Photoshop. Ayam Cemanis are amazing. They're all black, cone, beak, feathers, and even meat. It looked almost unreal from the online images I saw. Ayams have only been allowed in the states for two years, so it was difficult to find an owner. I finally found a small farm of exotic chickens and journeyed to capture a portrait of Krishna. Krishna puffed up his feathers and simultaneously stood up. His portrait has won multiple awards and is included in the 2016 *Communication Arts Photography Annual*.

18

Ruth

WHITE
COCKATOO

Ruth was "on" the day I photographed her. Exploring white-on-white tones is something I've always been interested in. It can be a challenge for photographers because you can easily lose detail in the whites. But within that challenge is a chance to show a subtle pattern and texture if exposed correctly. Working with Ruth was painless. She was social and literally speaking to us the entire time. Like many birds do, she puffed up her feathers, and I captured this single frame where the elements of white create a beautiful shape, texture, and form.

20 70 116
127

Felix

LION

Being in a studio with a big cat off leash is an incredible experience. The size and presence of a big cat is tangible, so powerful, and commands respect. Time flies, but at the same time, stands still. Felix is a celebrity cat for sure and has been featured in many commercials and movies. He's an old hat. His trainers are amazing, and it's evident seeing them work with Felix that their bond is strong and is mutually loving. When choosing exotic animals to work with in-studio, I either work with conservationists or with reputable trainers that I know treat their animals with the utmost respect and dignity they deserve.

21

Tuareg

LIONESS

Fierce Lady! Tuareg was a tough, vocal lioness and would 'speak' or chuff at us during the shoot. She was certainly a performer and would snarl on command. And because of that, she was rewarded the ultimate in-studio carnivorous treat... a drummy of course (short for chicken drumstick).

22

Julian

RING-TAILED
LEMUR

Julian had a lot to say and wanted to meet all of the crew. Lemurs are extremely sociable and very vocal. He didn't have an attitude per se but wanted to run the show and do things his way. Sometimes I have to oblige my talent and allow them to think they are the ones in control, and this was one of those instances. It's fine. He roamed around, and I was able to capture a few different profiles. This one feels spot-on, capturing his personality, charm, and humor.

23

Fez

ZEBRA

I photographed Fez during a larger commercial shoot. He was one of the main characters in front of a school bus for an advertising campaign. I was so fascinated by his markings that after the shoot I had to make a portrait of him. Fez was very agreeable and calm. I wanted to create a very simple portrait that showed off his stripes and texture.

24 102

Murphy

BLACK
LEOPARD

Murphy had me on my toes the whole time. He had a low growl the entire shoot, but by this time I knew the trainers well enough to know we were safe and Murphy was simply in his "work mode." It went so well, you could sense the mutual respect and admiration between him and his trainer. Sometimes referred to as panthers, they're actually a leopard that inherited a melanistic gene. The name "panther" comes from Panthera of the Felidae family.

25 46 100

Black Betty

AMERICAN
QUARTER
HORSE

Whoa, Black Betty (Bam-ba-Lam)... The stunning Black Betty is as famous as the song she was named after. Black Betty has won about every award a Quarter can win, and in the studio she did not disappoint. Like any celebrity, her shoot was short and sweet—in and out in ten minutes. She spent more time with our hair and makeup artist on those classic braids than she did in front of the camera. I've photographed many horses and I'm probably the most proud of the series of Black Betty. From the eyes of a horse lover, her posture and gaze are perfect. Ears forward, soft eyes, posture just right, not too low, not too high.

 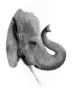 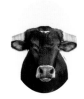 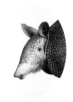 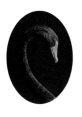 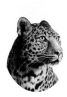 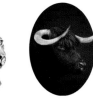

Bastina
LUSITANO HORSE

Eloise
AFRICAN ELEPHANT

Maverick
LONGHORN

Quesa
NINE-BANDED ARMADILLO

Luke
HORNED LIZARD

Stefani Angelina
BLACK SWAN

Sheena
SPOTTED LEOPARD

Domino
BLACK HIGHLAND COW

Like her name, Bastina was beautiful. A sexy, relatively unknown horse breed from Portugal, the Lusitano carries equal parts power and grace. She posed for the camera with ease and even reared up for us, showing off her long mane and sleek figure. When working with large-hooved animals in-studio, it's important they have proper footing, especially when performing moves like rearing up. To safely photograph Bastina, we placed 20 square feet of rubber flooring over the area where she would be standing.

Eloise had us all mesmerized by her sheer size. But equally as powerful was the serene nature of her personality. She moved softly with great care and tact. Despite her size, she could sense if she was about to step on something even an inch wide and so adjust her stride. I've photographed many animals, and I rarely have the chance to touch the animal I'm working with because of safety or comfort of the animal. But in this instance, I was able to put my hand on Eloise's shoulder and feel the wonderfully unique texture of her skin and wrinkles. I closed my eyes as I felt the rise and fall of her breath and felt an amazing sense of gratitude come over me. An amazing moment.

Maverick had mighty horns. He had a set much curvier that most steers. And they were so perfectly symmetrical that I really focused on their shape when composing my frames. Maverick is a Fort Worth native, and you can find him hanging out near the stockyards year-round, keeping the peace.

Quesa the Dilla. What else could you name an armadillo in Texas, right? Quesa came into the shoot pretty dirty and dusty, you know, because armadillos live underground. But I wanted a clean shot of ole Dilla, so after a lukewarm bath in tap water she was nice and shiny. We met Dilla through the one and only Sparky Sparks, expert Armadillo handler and race organizer. Quesa the Dilla, and in fact, all "Dillas" in North America are nine-banded armadillos.

Get your horns ready, Luke. I met Luke at the Dallas Zoo, where they're spearheading a conservation program with the Texas Parks and Wildlife to grow the horned lizard's population. Luke was tiny— like three inches tiny, tops—which was a challenge from a technical perspective. But he was a performer, lifting his head at just the right time, showing off those horns, and taking direction like a pro.

Black Swan, outlier. Black Swan, unpredictable. Black Swan, Extreme Impact. It is said a small number of black swans explains almost everything in our world, from the success of ideas and tradition, to the dynamics of historical events, to elements of our own personal lives. What's your black swan?

This portrait of Sheena is decidedly feminine. I've been lucky to have the amazing experience photographing big cats. I've created portraits of lions, tigers, cougars, panthers, cheetahs, and two spotted leopards. In person, the spotted leopard is without a doubt the most stunning. The spots, the pattern, the color, the strength, the grace is overwhelmingly beautiful. I hope my pictures do them justice. This is Sheena, who had such amazing and calming presence on set. Sadly, she passed away from a rare disease two months after this photograph was taken. She is dearly missed.

Domino, you have some wild horns. Dom's horns were asymmetrical, and from a straight on vantage point they looked totally wacky. So I really pursued a profile to show off the curvature, but what I didn't expect was how his horns would line up so nicely at this three-quarter angle. I photographed Domino on a beautiful ranch outside of Bozeman, Montana, on a sunny day. He definitely lives the life a Highland cow is meant too.

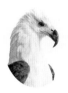
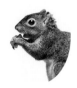
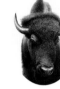
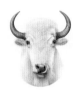
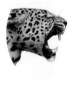
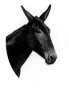
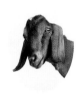

³⁶

Vincent

AFRICAN
FISH EAGLE

Oh Vincent, once he took the stage, it was clear to everyone why so many birds of prey are seen on flags, crests, and whatever needs to convey general badass-ery. With bowed head, Vincent demanded compositional balance and awe. Knowing he had the attention of everyone in the studio he calmly and gracefully directed the shoot.

³⁷

Merle

SQUIRREL

This Merle is a Squirrel. Ole Merle was much more relaxed on set than I expected. After sniffing around the tabletop, we quickly became comfortable. So much, in fact, that he demanded craft services. Craft services for a Squirrel is typically, wait for it...nuts. But not just any nuts. Merle requested shelled, unsalted pistachios. And boy, did it make him happy. He chowed down so much that we shot him with pistachio in hand. If there's such a thing as the classic pose for a squirrel, this, my friends, is it.

³⁸

Red Cloud

AMERICAN
BUFFALO

Holy Buffalo! If you think cows are big, get in a room with a Buffalo. On set, this massive beast had us in awe. Named in homage to the great Native American leader Red Cloud, he had a presence I will never forget. A gravitas that demanded respect and caution. He was a gentle giant. On May 13th, 2016, President Obama signed legislation honoring the American buffalo as this country's first national mammal.

³⁹

Huckleberry

WHITE
AMERICAN
BUFFALO

A gentle giant, Huckleberry was a sweet one for sure. In person, the size and presence of a buffalo is amazing. It's humbling, actually. Huckleberry is a white buffalo, not an albino buffalo. They are extremely rare, approximately one out of every ten million. Seriously! Because of their rarity, White Buffaloes have been considered spiritually significant in several Native American traditions, and to this day they are considered a sign of peace and harmony.

⁴⁰

Cairo

SPOTTED
LEOPARD

Cairo was a curious cat. On leash, he wanted to check out the studio and get a feel for the place. But when it was time to work, he was ready and wanted to. His owner told me that Cairo loves to snarl, but once we start doing it he wouldn't want to stop. So, at the end of the shoot, Cairo hopped on his pedestal and was ready to snarl. And boy did he! His owner would say, "sssssssspeak!" Cairo would snarl and then receive the best big cat snack, a chicken drumstick, or "drummy," for short. I was three feet from him when I shot this, and the feeling being this close to this sort of power was incredible and humbling. I'll never forget it.

⁴²

Milo

JOHN MULE

While Milo might be a smartass, he's no ass. So let's clarify what a mule is. A mule is the offspring of a male donkey (jackass) and a female horse (mare). A mule has the athletic ability of a horse and the intelligence of a donkey. And, yes, the ears of a donkey. They are a kind, hardworking breed that has been around for millennia. They are thought to be the first manmade crossbreeds. For my horse portraits, I would almost always choose an image where both ears were forward, but it felt fitting to do something a little different with Milo. The cross of his ears makes the perfect "X" shape with his head. I think it also shows his intelligence. He's listening to you and, at the same time, eavesdropping on the table behind him.

⁴³

Sammy

BROWN GOAT

Sammy waltzed into the shoot, ready for attention. He wanted goat treats and a scratch behind the ears from everyone. While on set, it seemed clear to me the shot needed to be humorous and fun. After a few minutes of walking around, he peaked his head into the set area and I captured this great face. It makes me smile, and I hope it does the same for you.

⁴⁵

Theodore

AMERICAN
QUARTER
HORSE

Theodore was a specimen, exuding the beauty of natural design. He was raw power, whose muscles rippled under his short summer coat. After directing the lights, his metallic-like sheen looked almost other-worldly. In short, Theo was a stud.

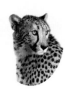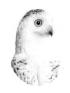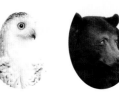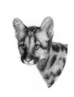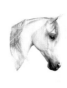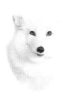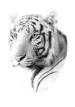

Yohan

CHEETAH

Poppy

SNOWY OWL

Roberta

BLACK BEAR

Pete

MOUNTAIN
LION CUB

*Sergeant
Pepper*

WHITE ARABIAN
HORSE

Vicki

ARCTIC FOX

Caesar

SIBERIAN
WHITE TIGER

Carnita

POT-BELLIED
PIGLET

Yohan and his fifth gear. I grew up a track & field sprinter, and consequently I have always had a love for Cheetahs so it was amazing to see Yohan in person. He was distinguished and calm. He resides outside of Dunlap, California, at one of the most amazing large-cat sanctuaries I've ever seen. The founder of the organization is continually pushing efforts for large-cat conservation and protection. On our outdoor mobile studio, Yohan was easy going, interested in playing with a large cat toy, chasing it around like he was a cub. At the sanctuary, they have a 400-square-yard open area for Yohan to show off his speed.

Poppy's gorgeous yellow irises were a focal point for her portraits. Owls are one of the most expressive animals I've photographed. Their eyes tell a story unlike any other creature. I wanted to show three likenesses of her: one of intensity, one of humor, and one more contemplative. Poppy cooperated and was a fantastic model. She is currently traveling the world with her owner working to educate the world about owls and other birds of prey.

Roberta was a doll. She happily posed for us but demanded sweets like any self-respecting bear would. Despite many bears' desires for junk food of all kinds, Roberta demanded pure, local honey for her main treat. Her kind trainers did not deny. Sometimes an animals gives me just a glimmer of their personality or an expression. I was so happy to see that I caught her eye looking off for a split second. Maybe it was for the honey, or maybe she was eyeing my assistant.

Pete had some serious speed and this three-month-old cub was a amazing. He wanted to run, he wanted to play, but he really didn't want to sit still. We were able to get his attention using some small cat toys that he loved. But I was only able to capture a few frames, this being one of my favorites. It's a sweet profile showing off his cat genes, but by the size of those paws you know Pete's going to be a big cat.

The learning curve to photograph horses is significant. There are many subtleties that should be acknowledged when creating the perfect portrait of a horse. Those subtleties can sometimes be different depending on the breed. One of the most famous and identifiable horses is the Arabian horse. The portrait of Sergeant Pepper embodies many of their famous traits. A chiseled head, dished face, long neck, and attentive eyes. Sergeant Pepper exudes energy, intelligence, and nobility. His mane says it all.

Nothing could outfox Vicki. In my experience, foxes and domestic cats have been the most challenging subjects. Both skittish by nature, it took patience, fox snacks (almonds & fruit), and a little serendipity to catch her in a pose that I think speaks volumes about the elusive subject.

Caesar was a massive Siberian white tiger but extremely calm around all of us. For this pose, Caesar was lying down with his chest and belly on the ground and his head up. Which is similar to how a domestic cat 20 times smaller lays down or sits. But with his head up, this pose felt relaxed and distinguished. If you look closely though, there is an intensity in his eyes as if he's looking for something in the distance, waiting for it to get closer and closer.

Carnita is piglet perfection. I mean, come on—look at her! I couldn't really take a bad picture of Carnita. Her coloring couldn't have been more perfect. The gray stripe, the black on top, and that ridiculously cute face: perfect. She did not have much of a belly at the time of our shoot, but by now I can only hope she's pleasantly plump.

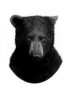 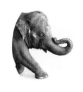 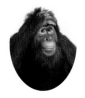 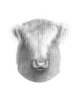 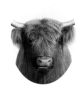 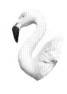 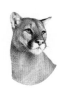

 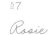

56

Andre

BLACK BEAR
CUB

Andre was ready to roll. He was about six months old and already growing up to be a big boy. He waddled around the set and socialized with the crew. His favorite in-studio treat? Marshmallows, of course.

57

Rosie

ASIAN
ELEPHANT

What a memory, Rosie! It's not often that I have the chance to take one of my kids on a photoshoot. But the timing for Rosie worked perfectly for my 8-year-old, Layla, to join me on set. From the moment Rosie stepped out of her trailer (yes, she's a celeb), Layla and I were mesmerized. Being in her presence was an honor. She was so calm and so graceful—a serene beauty. At the end of the shoot, Rosie wrapped her trunk around Layla and lifted her six feet off the ground! That was a moment we will never forget!

58

Danielle

ORANGUTAN

What are you thinking, Danielle? My interest in showcasing human expression and emotion in animal portraiture is most obvious in my photographs of primates. You don't have to spend much time around primates to see ourselves in them, and Danielle gave me a look with her hand on her head and eyes right at camera. What's she thinking? Well...that all depends on what you're thinking.

60

Goldie

HIGHLAND
CALF

The golden calf.... As many cows as I've included in this book, Goldie is the one and only calf. As you can see her hair was smooth and a beautiful golden color. And because she can't see, she'll have to take our word on it.

61

Beverly

HIGHLAND
COW

Beverly is the classic Highland cow. Redhead, long hair, shapely horns. On set, she knew it, though. Bev was a bit of a diva and had to be coaxed on set with some cow cookies and, even then, wouldn't stay still for us. The others in the herd look up to her as if she knows what's what. But the truth about Bev is that she just wants to be heard and seen. Don't we all?

62 63

Alejandra

FLAMINGO

Alejandra made us take our hats off. Mother Nature never fails to impress, and the color and shape of this South American beauty did not disappoint. Alejandra's pastel pink feathers juxtaposed with the bright coral red under her wings were just stunning. And the oh-so-perfect S curve of her neck had all of us on set mesmerized by her beauty.

69 122

Dexter

MOUNTAIN
LION

Dexter, I'll never forget you. Photographing big cats are an experience unlike photographing any other animal. The combination of power and grace within the animal is not only tangible but can be frightening. They command respect, and one wrong move and things could escalate quickly. Dexter, a one-year-old mountain lion (cougar, puma— same thing) had a low rumbling growl the entire time we had him in studio. The trainers were feeding him raw chicken, and he was using his hands to grab it off the feed stick. Dexter swiped at the chicken, and it landed at my feet. He jumped off the riser he was sitting on, and came down to eat the chicken at my feet. The fear inside me was literally like a rushing wave drowning me. But I knew damn well not to move. I took a deep breath, HUGE deep breath, as the trainer gently walked Dexter back up on the riser, luring him with more chicken.

72

Malekeh

PERSIAN
IBEX

Malekeh and his massive horns made us in the studio a little nervous. But once he settled and hit the craft services (corn—non-GMO, of course), he was just fine. Undoubtedly, the profile is the shot I was after. Those horns were stunning, but what I didn't expect was the guru-like long goatee seen in this profile. Malekeh's ancestors are found throughout Europe, Asia, and the Middle East. And they've been illustrated and have inspired men as early as the Paleolithic era.

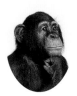 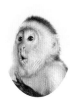 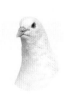 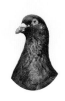 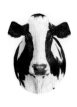 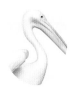

Amari

CHIMPANZEE

Compared to his brother, Amari was a bit more calm and relaxed on set. I thought it would be interesting to further anthropomorphize him by placing Amari in a very human position. He was agreeable and was happy to pose for us. This shot in particular was inspired by the famous Auguste Rodin's *The Thinker*. Throughout the shoot, Amari would run around, dance, and then jump into my arms for a hug. A funky monkey, no doubt.

George

CAPUCHIN MONKEY

Phew, George had some pipes! The little fellow only stood about two feet tall, so I wasn't intimidated on set—until he screamed at me during our shoot! In that moment, glass shattered, and, all of a sudden, this cute monkey made me jump two feet. I'm happy to say we both made it and he gave me this shot. I like to think he's blowing fairy dust from his hands.

Pax

HOMING PIGEON

Although he looks like a white dove, Pax is actually a white homing pigeon. White pigeons are what are generally used in ceremonies to symbolize peace and what most people think of when they see a white dove. I photographed Pax on a small French farm, and he was very challenging. We would set him down with some birdseed, and I'd capture one to two frames, and then he'd take off. I knew I wanted a simple, clean profile, so that's the shot we focused on in our limited time.

Shilo

HOMING PIGEON

Once again, I marvel at the beauty of Mother Nature. I love the subtle iridescent pops of turquoise and purple. Like her friends Milo and Pax, Shilo proved tough to photograph because, stating the obvious, she's a bird and has a propensity to fly. So, in our limited time, we tried to capture, simple, clean profiles showing off her beauty.

Hattie

FRAZZLE CHICKEN

Hattie was quite a site. Although the term "frazzle" refers to her curly hair caused by a recessive gene, Hattie's personality fit the bill, too. She was hyperactive, running around like crazy, glancing this way and that way, but eventually succumbed to my camera. From a visual perspective, I love the small pop of red in the mostly white-and-cool canvas.

Maxine

DAIRY COW

Maxine was calm, cool, and collected. Cows were my first journey into the world of animal photography and they are still my favorite subjects. She's made many appearances on TV commercials and movies. I guess Maxine is as close to a celebrity cow as there is. Her performance in studio did not disappoint, and my desire for a straight-on, clean portrait came with ease. One note about celebrity cows is their bathroom breaks are so substantial (i.e. voluminous), a member from her entourage stands close by on set ready to jump in with a large bucket to catch her... ahem, digestive elimination, shall we say.

Luna

DUCKLING

Luna was adorable. I mean, c'mon. Look at her! She was only 2 weeks old when I photographed her in a country barn outside of Austin, Texas. She waddled around quickly and stopped for just one second here to stretch her feathers. Even though it was summer, young ducklings love (and need) heat, so we had warm heat lamps on the tabletop we photographed her on, which she soaked up like the summer sun. Cuteness resides here.

Juliet

GREAT WHITE PELICAN

Many models are tall, and Juliet was no exception. The top of her head was almost four feet. Her beauty was captivating. She was perfect, almost surreal. Unlike many birds, the feathers on her body were tiny, giving her white coat a smooth look instead of rough feathers like most birds. During the shoot, craft services served large sardines and small fish to snack on. When she took down a fish, the expansion of her beak was just incredible. I absolutely love the gray tones on the equally luminous gray background.

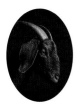 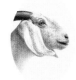 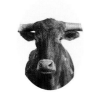 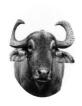 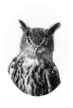 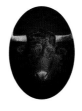 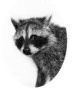 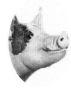

№6

Oscuro

BLACK GOAT

Oscuro, the dark side of the moon. All black, Oscuro is truly majestic and melanistic—even his horns are naturally black. His namesake means dark in Spanish and contrasts beautifully next to his fare counterpart Bianca.

№7

Bianca

WHITE GOAT

Bianca, the light of the moon. Something about the gorgeous, white dappling of Bianca reminds me of the moon. The highlights and shadows play together like the craters and peaks on the moon. The soft light gives her a beautiful glow and effervescent vibrancy. It fascinated me the way her ears floated, like she's suspended in the celestial ether.

№9

Patron

LONGHORN

Patron had a lovely brindle color to his coat. His horns had a nice curve to them and his face was very masculine. There's a richness to his coat and pose that I find distinguishes him and his name, Patron, so fitting.

№0 №1

Lao Tzu

ASIAN WATER BUFFALO

The old sage, Lao Tzu. My intention with him was to center on his impressive horns and show how a simple change in angle could cast a subject in many different lights. Like the wisdom his namesake was known for, Lao Tzu's dance with light was illuminating.

№2

Walter

GREAT HORNED OWL

Wise owl Walter was a resident of the Southeastern Raptor Center. He was rehabbing an old wing before being released out into the wild again. Without a doubt, owls are one of the most expressive animals I've photographed. They move their head and eyes constantly, taking note of everything around them—observers of details, which I too can appreciate. He gave us plenty of good looks, and, after much deliberation, I settled on this photo as my favorite.

№3

Santiago

TORO BRAVO

Santiago demanded respect. When you're in the presence of a bull, you must be cautious. They are powerful, quick, and their short horns can be dangerous. Fortunately, our shoot with Santiago was a peaceful one. My goal with Santiago was to create a portrait that shows the powerful nature of a bull and, at the same time, show respect and admiration. Santiago, you are well respected.

№4

Lewis

RACCOON BABY

Like all young animals, Lewis was a speed demon. And a mischievous little guy. He was getting into everything in the studio, completely unphased by the camera, lights, or my crew. When he finally showed up on the set, he didn't stay long, but I captured around 30 frames and this one was it. The shot showed off Lewis's mischievous and youthful spirit. It's like he's looking around at me saying, "don't tell my mom."

№5

Rupert

PINK PIG

Big boy Rupert. You should see his hams. Phew wee! I photographed Rupert at the Texas State Fair, and this year he won the best of show. This is one fancy show pig and boy did he have quite a stage presence. He waddled on set and was well behaved during our shoot. His reward you ask? Marshmallows. Rupert went to town on Marshmallows.

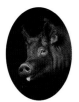
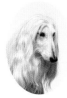
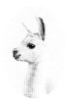
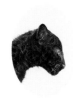
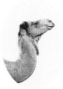
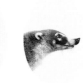
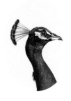
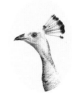

№ 6

Jethro

BLACK PIG

№ 7

Kurt

AFGHAN
HOUND

№ 8

Tina

LLAMA BABY

№ 101

Dante

BLACK
LEOPARD CUB

№ 103

*Juan
Carlos*

DROMEDARY
CAMEL

№ 104

Olmec

RING-TAILED
COATI

№ 105

Isaac

BLUE
PEACOCK

№ 106

Lucy

GRAY
PEACOCK

Ole Jethro, what a character. Jethro's been a show pig his whole life, which means he's kind of a big deal in parts of the world. Pigs are super intelligent—as in, one of the top five smartest animals on the planet. But he sure was stubborn. During our shoot, we tried desperately just to get his head off the ground. Because you know, pigs heads are designed to literally be on the ground. What finally did the trick? A water mister. Pigs can't sweat, that's why they roll around in wet mud. Well, we didn't have a trough of mud, so instead we just gave him a nice soft mist of water, which he loved and kept moving his head towards. Phew!

A rock star of a dog, Kurt was a pro on set. His smooth locks, which parted down the middle, humanized him perfectly. Unlike his grunge rock predecessor, Kurt chose to omit the angst and keep it clean and smooth.

Tina was a doll in the studio. She loved being around people and would always stand still for an ear scratch or, even better, llama treats. At the time, she was about four months old, so still a little babe. I love the simple profile showing off her style, form, and big eyes.

Black leopard cub Dante was about two months old when I photographed him. Like other baby animals, he was fast as lightning! So, it seemed fitting to try to capture a shot of him midgait. I shot maybe 100 frames of him and somehow managed to grab this profile where his legs and tail just look perfect. If you look closely, you can see the classic leopard spots in Dante's skin. Sometimes referred to as panthers, black leopards are a leopard that inherited a melanistic gene. The Panthera genus includes lions, tigers, spotted leopards, snow leopards, and jaguars.

Juan Carlos is a traveler. He's made many trips throughout the rugged Southwest Texas region, and even crossed the border to venture into the Sierra Madre Mountains of Mexico. He prefers to spend his time in the high-desert plains near Marfa. For our photoshoot, we met in an airplane hanger outside of Waco, Texas—seriously! Juan Carlos was a prince on set, without an ego, of course. He even let me take a quick stroll on his back.

One step. Two step. Stop. Tail up. Perfect pose, Olmec. Ring-tailed Coati's are everywhere in Central America. So much so that we even had one walk up to us on a beach on the Yucatán Peninsula. Olemec takes his namesake from the earliest known major civilization in Mexico. The Olmec's lived in the tropical lowlands of south-central Mexico, in the present-day states of Veracruz and Tabasco. If you see Olemec in his native habit, give him my regards.

Isaac is an Austinite. A local resident at the Austin Zoo & Sanctuary, he spends his days entertaining guests and children in this rustic natural sanctuary. When we showed up with our camera, he was happy to spend a few minutes with us. As I saw the light hit his beautiful feathers, I knew it would create a wonderful likeness. His color is almost luminescent and metallic. Once again, I left the shoot with Isaac marveling at the beauty of Mother Nature and her Animal Kingdom.

Lucy spends her days at the Austin Zoo and Sanctuary with her fellow peacock Austinite and good friend Isaac, the Blue Peacock. Lucy is quite charming with the guests and little kids, always ready for a bit of birdseed from them. Her wonderful gray tones are caused by a recessive gene and are rare in the world of peacocks.

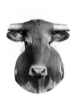

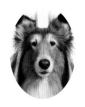

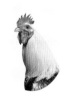

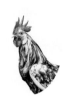

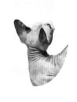

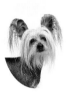

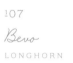

107

Bevo

LONGHORN

It was an honor that I had the chance to photograph University of Texas mascot Bevo XIV when he was still alive. So when *The Alcalde*—the publication of the Texas Exes—called and asked if I would be willing to photograph Bevo XV for his debut, I was equally excited and honored. We created this portrait of Bevo XV for the September cover of *The Alcalde* and I couldn't be more happy with how it turned out.

108

Reveille

ROUGH COLLIE

Reveille Call! I've photographed over a hundred different animals for this book, so it was only fitting that I photograph the mascot from my alma mater, Texas A&M. I'm a proud Aggie, and our first lady Reveille was an easy subject. Truly man's best friend. I would say smarter and better looking than many of my subjects, namely those, ahem...steers.

109

Garth

AMERICANA ROOSTER

With a name like Garth, what's not to like? This masculine cock strutted in the studio with his feathers up, looking for ladies. Fortunately for us, there were none—just some boring seed for the good-looking guy. He certainly posed for us though, and I loved how the light picked up with the classic Americana colors of his coat.

110

Hugo

ORUST ROOSTER

Originally from Sweden, the gregarious Hugo had swagger. Orusts are a rare breed, with less than 1000 known living in the world and typically a more wild chicken by appearance. You can see from Hugo's profile that he is leaner and more muscular than a typical rooster. He also wears a beautiful black and white feathery coat, has spotted legs, and his ear lobes are white. Seriously cool, seriously unique. Pair Hugo up with these other roosters!

113

Helen

SPHINX CAT

What a pose, Helen! Despite most of my animal collection being that of the wild type, domestic cats are of one of my most unpredictable subjects. Helen was no exception. Because of her unique lack of fur, every move she made showed off her form and grace. This shot shows the cat in a classic pose, and maybe even a little pretend cat-and-mouse?

114

Chauncey

CHINESE CRESTED DOG

Chauncey looked at the camera like someone just busted in and shaved her hair off. As if, "Really? Not again!" But she's made that way. A Chinese crested dog with a furry face and tail, but body? Not so much.

115

Bandit

SKUNK

When I started the animal portrait series, I always thought it would be amazing to create a portrait of a skunk. Of course, the challenge with many of my pieces is finding animals that are tame enough to sit through one of my portrait sessions. After months of emailing and weaving through a web of friends and animal owners, I found someone who had rescued Bandit when he was a baby and had nursed him back to health. Many ask, "Did he spray you?" Let's just say I didn't have to take a tomato bath.

117

Valentino

BENGAL TIGER CUB

Like many cubs and kittens, little Tino wouldn't sit still for us long. The frame I ended up choosing is him looking down showing the profile and striping of his face and body. Soft, cute, and cuddly, but I couldn't help but imagine Valentino growing into the magnificent animal he's going to be. The shot is the making of the roar.

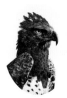
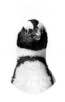
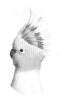
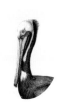
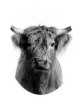
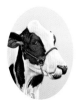

Martial Eagles are perhaps the deadliest living raptor species. They are what are known as an Apex Predator. They have a massive, seven-foot wing span and have four times the eye acuity as a human, which means they can spot their prey up to three miles away. Because of their size and eyesight, they are known to prey on mammals as large as deer or antelopes. Fortunately for us, Zane decided that we weren't prey and was agreeable on posing a few minutes for us.

Take flight, Amelia! This beautiful Pink Cockatoo is native to Australia. Her color is stunning, graphic, and vibrant. During our shoot, her head feathers would flutter up and down creating a spectacle and drawing attention from everyone on set. What's interesting about Amelia is she loves mirrors. I can understand why she couldn't get enough of herself—I mean, she is a looker!

Who doesn't like a penguin named Kowalski? African penguins are sometimes referred to as black-footed penguins or jackass penguins (for their loud, donkey-like call). This penguin, Kowalski, was quite the performer in the studio. He waddled around, gobbled up fish, talked a lot, and very occasionally would puff his small feathers out, like so many birds do. One thing that is interesting about penguins is that they truly smell like fish. I guess the old adage, "you are what you eat," holds true for them.

Alfonzo, the amazing. While on assignment for *Audubon* magazine, I was working with a rescue organization in Corpus Christi, Texas, that was helping rehab birds affected by the Gulf oil spill. Alfonzo was on-site and had already been cleaned up and on his way back to good health. For our shoot, he received large sardines and other fish as treats. If you've never seen a pelican eat a fish, trust me, it's amazing how much their beak can expand to accommodate the fish it consumes.

Eleanor is the perfect example that imperfect can be oh-so-perfect. Unlike her Highland girlfriends, she has short and messy hair, a dark sandy coat, and short, asymmetrical horns. But what's so perfect about Eleanor is that she owns it. She's comfortable in her own hide, and that self-confidence clearly shines through in this portrait. Per their name, Highland cows are originally from the Highlands of Scotland.

This series of colorful cows is what started the animal portrait collection. Renowned designer DJ Stout of Pentagram commissioned me to photograph a series of dairy cows in front of bright, poppy backgrounds. On a cold, rainy November day, we traveled to a small dairy farm and set up our studio lights and color backgrounds. That day, we brought to life the personalities of these wonderful cows. And I saw the potential of translating my people portraiture into animal portraiture. Since then, this series of cows has been collected across the world and been an inspiration to me as I continue to explore the art and aesthetics of animal portraiture.